TO THE PROMISED LAND

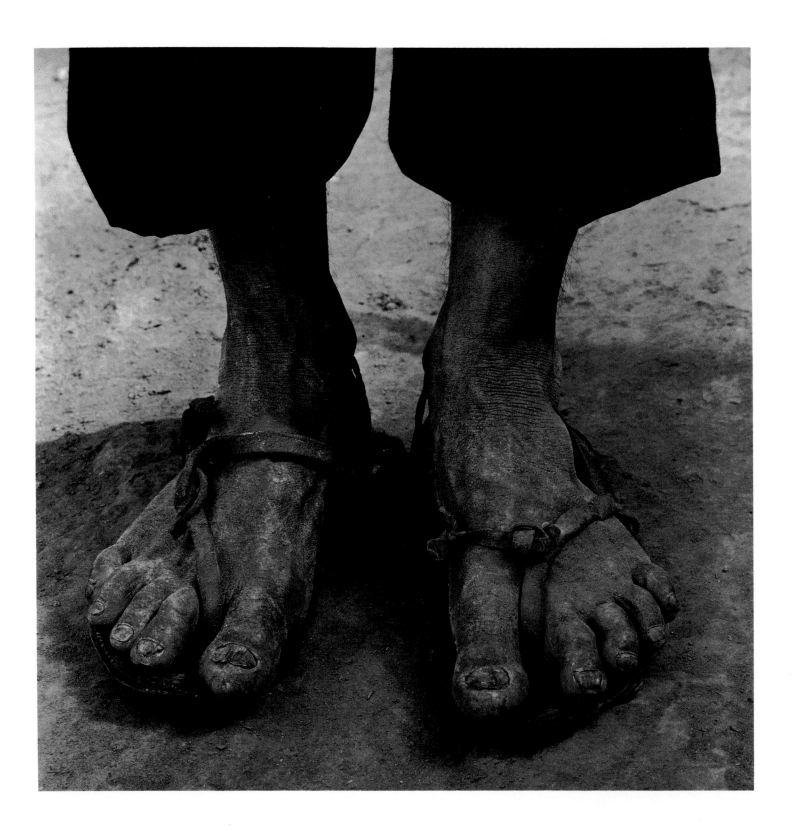

TO THE PROMISED LAND

PHOTOGRAPHS BY KEN LIGHT

INTRODUCTION BY RICHARD RODRIGUEZ

Essay by Mary Jo McConahay
Oral histories by Samuel Orozco

AN APERTURE BOOK
In Association with the California Historical Society

*We people are forced to emigrate
to other places even though we
love our land.*

—Pablo G., 29, Oaxaca

Proofs

by Richard Rodriguez

You stand around. You smoke. You spit. You are wearing your two shirts, two pants, two underpants. Jesús says if they chase you, throw that bag down. Your plastic bag is your mama, all you have left: the yellow cheese she wrapped has formed a translucent rind; the laminated scapular of the Sacred Heart nestles, flame in its cleft. Put it in your pocket. Inside. Put it in your underneath pants' pocket. The last hour of Mexico is twilight, the shuffling of feet. Jesús says they are able to see in the dark. They have X-rays and helicopters and searchlights. Jesús says wait, just wait, till he says. Though most of the men have started to move. You feel the hand of Jesús clamp your shoulder, fingers cold as ice. *Venga, corre.* You run. All the rest happens without words. Your feet are tearing dry grass, your heart is lashed like a mare. You trip, you fall. You are now in the United States of America. You are a boy from a Mexican village. You have come into the country on your knees with your head down. You are a man.

Papa, what was it like?
I am his second son, his favorite child, his confidant. After we have polished the DeSoto, we sit in the car and talk. I am sixteen years old. I fiddle with the knobs of the radio. He is fifty.
He will never say. He was an orphan there. He had no mother, he remembered none. He lived in a village by the ocean. He wanted books and he had none.
You are lucky, boy.

In the nineteenth century, American contractors reached down into Mexico for cheap labor. Men were needed to build America: to lay track, to mine, to dredge, to harvest. It was a man's journey. And, as a year's contract was extended, as economic dependence was established, sons followed their fathers north. When American jobs turned scarce—during the Depression, as today—Mexicans were rounded up and thrown back over the border. But for generations it has been the rite of passage for the poor Mexican male.
I will send for you or I will come home rich.

In the fifties, Mexican men were contracted to work in America as *braceros,* farm workers. I saw them downtown in Sacramento. I saw men my age drunk in Plaza Park on Sundays, on their backs on the grass. I was a boy at sixteen, but I was an American. At sixteen, I wrote a gossip column, ''The Watchful Eye,'' for my school paper.
Or they would come into town on Monday nights for the wrestling matches or on Tuesdays for boxing. They worked over in Yolo county. They were men without women. They were Mexicans without Mexico.
On Saturdays, they came into town to the Western Union office where they sent money—money turned into humming wire and then turned back into money—all the way down into Mexico. They were husbands, fathers, sons. They kept themselves poor for Mexico.
Much that I would come to think, the best I would think about male Mexico, came as much from those

chaste, lonely men as from my own father who made false teeth and who—after thirty years in America—owned a yellow stucco house on the east side of town.

The male is responsible. The male is serious. A man remembers.

Fidel, the janitor at church, lived over the garage at the rectory. Fidel spoke Spanish and was Mexican. He had a wife down there, people said; some said he had grown children. But too many years had passed and he didn't go back. Fidel had to do for himself. Fidel had a clean piece of linoleum on the floor, he had an iron bed, he had a table and a chair. He had a coffee pot and a frying pan and a knife and a fork and a spoon, I guess. And everything else Fidel sent back to Mexico. Sometimes, on summer nights, I would see his head through the bars of the little window over the garage at the rectory.

The migration of Mexico is not only international, South to North. The epic migration of Mexico, and throughout Latin America, is from the village to the city. And throughout Latin America, the city has ripened, swollen with the century. Lima. Caracas. Mexico City. So the journey to Los Angeles is much more than a journey from Spanish to English. It is the journey from *tu*—the familiar, the erotic, the intimate pronoun—to the repellent *usted* of strangers' eyes.

Most immigrants to America came from villages. The America that Mexicans find today, at the decline of the century, is a closed-circuit city of ramps and dark towers, a city without God.

It is 1986 and I am a journalist. I am asking questions of a Mexican woman in her East L.A. house. She is watchful and pretty, in her thirties, she wears an apron. Her two boys—Roy and Danny—are playing next door. Her husband is a tailor. He is sewing in a bright bedroom at the back of the house. His feet work the humming treadle of an old Singer machine as he croons Mexican love songs by an open window.

For attribution, mama says she is grateful for America. This country has been so good to her family. They have been here ten years and look, already they have this nice house. Outside the door is Mexican Los Angeles; in the distance, the perpetual orbit of traffic. Here old women walk slowly under lace parasols. The Vietnam vet pushes his tinkling ice cream cart past little green lawns. Teenagers in this neighborhood have scorpions tattooed onto their biceps.

The city is evil. Turn. Turn.

At 16th and Mission in San Francisco, young Mexican Americans in dark suits preach to the passing city from perfectbound Bibles. They pass leaflets for Victory Outreach—"the junkie church."

In Latin America, Catholicism remains the religion of the village. But in the city now, in Lima as in Los Angeles, more and more souls rap upon the skin of the tambourine for the promise of evangelical Protestantism: you can be cleansed of the city, you can become a new man, you can be born again.

The raven-haired preacher with a slash on his neck tells me his grandmother is from Jalisco, Mexico. His mother understood Spanish but she couldn't speak it. She couldn't do anything right. She was a junkie. She had him when she was seventeen. She disappeared.

"I lived out on the streets. Didn't go past seventh grade. Grass, crack, dust—I've had it all; messed up with gangs, rolled queers. I've stabbed people, man, I've stuck the blade all the way in and felt a heart flutter like a pigeon.

"I was a sinner, I was alone in the city. Until I found Jesus Christ. . . ."

The U.S. Border Patrol station at Chula Vista has a P.R. officer who handles journalists; he says he is glad to have us—"helps in Washington if the public can get a sense of the scope of the problem."

Right now he is occupied with a West German film crew. They were promised a helicopter. Where is the

helicopter? Two journalists from a Tokyo daily—with five canvas bags of camera equipment between them—lean against the wall, arms folded. One of them brings up his wrist to look at his watch. A reporter from Chicago catches my sleeve, says, Did I hear about the other night? What? There was a carload of Yugoslavians caught coming over.

The Japanese reporter who is not looking at his watch is popping CHEEZITS into his mouth. The Border Patrol secretary has made some kind of mistake. She has me down as a reporter for *American Farmer.* Fat red steer in clover. Apologies. White-out. "I . . . agree to abide by any oral directions given to me during the operation by the officer in charge of the unit. . . ." Having signed the form, I am soon assigned a patrolman with whom I will spend the night.

We stop for coffee at a donut shop along the freeway. The patrolman tells me about growing up Tex-Mex in Dallas. After City College, he worked with an anti-poverty agency. Then he was a probation officer. He got married, needed money, moved to California and took this job with the *migra.*

Once into the dark, I cannot separate myself from the patrolman's intention. We ride through the dark in a Ram Charger, both intent upon finding people who do not want to be found.

We come upon a posse of Border Patrolmen preparing to ride into the canyon on horseback. I get out of the truck; ask the questions; pet the horses in the dark, prickly, moist, moving in my hand. The officers call me sir. It is as though I am being romanced at some sort of cowboy cotillion. "Here," says one, "have a look." He invites me so close to his chin I can smell cologne as I peer through his night-vision scope.

Mexico is on the phone—long distance.

A crow alights upon a humming wire, bobs up and down, needles the lice within his vest, surveys with clicking eyes the field, the cloud of mites, then dips into the milky air and flies away.

Juanito killed! My mother shrieks, drops the phone in the dark. She cries for my father. For light.

The earth quakes. The peso flies like chaff in the wind. The police chief purchases his mistress a mansion on the hill.

The door bell rings. I split the blinds to see three nuns standing on our front porch.

Mama. Mama.

Monsignor Lyons has sent three Mexican nuns over to meet my parents. The nuns have come to Sacramento to beg for Mexico at the eleven o'clock mass. We are the one family in the parish that speaks Spanish. As they file into our living room, the nuns smell pure, not sweet, pure like candles or like laundry.

The nun with a black mustache sighs at the end of each story the other two tell. Orphan. Leper. Crutch. Dry land. One eye. Casket.

¡Que lastima!

But the Mexican poor are not bent. They are proof of a refining fire.

The Mexican nuns smile with dignity as they stand after mass with their baskets extended, begging for Mexico.

A dusty black car pulls up in front of our house. My uncle has brought his family all the way from Ciudad Juarez. During their visit, my mother keeps trying to give them things to take back. There is a pair of lamps in the living room with porcelain roses. My aunt's eyes demur with pleasure to my uncle. My uncle says no. My uncle says his sister's children (I am the only one watching) would get the wrong impression of Mexico.

Mexico is poor. But my mama says there are no love songs like the love songs of Mexico. She hums a

song she can't remember. The ice cream there is creamier than here. Someday we will see. The people are kinder—poor, but kinder to each other.

My mother's favorite record is *"Mariachis de Mexico y Pepe Villa con Orchestra."* Every Sunday she plays her record (*"Rosas de Plata"*; *"Madrecita Linda"*) while she makes us our pot-roast dinner.

Men sing in Mexico. Men are strong and silent. But in song the Mexican male is granted license he is otherwise denied. The male can admit longing, pain, desire.

HAIII—EEEE—a cry like a comet rises over the song. A cry like mock-weeping tickles the refrain of Mexican love songs. The cry is meant to encourage the balladeer—it is the raw edge of his sentiment. HAI-II-EEEE. It is the man's sound. A ticklish arching of semen, a node wrung up a guitar string, until it bursts in a descending cascade of mockery. HAI. HAI. HAI. The cry of a jackal under the moon, the whistle of the phallus, the maniacal song of the skull.

Tell me, Papa.
What?
About Mexico.
I lived with the family of my uncle. I was the orphan in the village. I used to ring the church bells in the morning, many steps up in the dark. When I'd get up to the tower I could see the ocean.
The village, Papa, the houses too. . . .
The ocean. He studies the polished hood of our beautiful blue DeSoto.

Mexico was not the past. People went back and forth. People came up for work. People went back home, to mama or wife or village. The poor had mobility. Men who were too poor to take a bus walked from Sonora to Sacramento.

Relatives invited relatives. Entire Mexican villages got recreated in three stories of a single house. In the fall, after the harvest in the Valley, families of Mexican adults and their American children would load up their cars and head back to Mexico in caravans, for weeks, for months. The school teacher said to my mother what a shame it was the Mexicans did that—took their children out of school.

Like wandering Jews. They carried their home with them, back and forth; they had no true home but the tabernacle of memory.

Each year the American kitchen takes on a new appliance.
The children are fed and grow tall. They go off to school with children from Vietnam, from Kansas, from Hong Kong. They get into fights. They come home and they say dirty words.

The city will win. The city will give the children all the village could not—VCRs, hairstyles, drum beat. The city sings mean songs, dirty songs. But the city will sing the children a great Protestant hymn.
You can be anything you want to be.

We are parked. The patrolman turns off the lights of the truck—"back in a minute"—a branch scrapes the door as he rolls out of the van to take a piss. The brush crackles beneath his receding steps. It is dark. Who? Who is out there? The faces I have seen in San Diego—dishwashers, janitors, gardeners. They come all the time, no big deal. There are other Mexicans who tell me the crossing is dangerous.

The patrolman returns. We drive again. I am thinking of epic migrations in history books—pan shots of

orderly columns of paleolithic peoples, determined as ants, heeding some trumpet of history, traversing miles and miles . . . of paragraph.

The patrolman has turned off the headlights. He can't have to piss again? Suddenly the truck accelerates, pitches off the rutted road, banging, slamming a rock, faster, ignition is off, the truck is soft-pedalled to a stop in the dust; the patrolman is out like a shot. The cab light is on. I sit exposed for a minute. I can't hear anything. Cautiously, I decide to follow—I leave my door open as the patrolman has done. There is a boulder in the field. Is that it? The patrolman is barking in Spanish. His flashlight is trained on the boulder like a laser, he weaves it along the grain as though he is untying a knot. He is: Three men and a woman stand up. The men are young—sixteen, seventeen. The youngest is shivering. He makes a fist. He looks down. The woman is young too. Or she could be the mother? Her legs are very thin. She wears a man's digital wristwatch. They come from somewhere. And somewhere—San Diego, Sacramento—somebody is waiting for them.

The patrolman tells them to take off their coats and their shoes, throw them in a pile. Another truck rolls up.

As a journalist, I am allowed to come close. I can even ask questions.

There are no questions.

You can take pictures, the patrolman tells me.

I stare at the faces. They stare at me. To them I am not bearing witness; I am part of the process of being arrested. I hold up my camera. Their eyes swallow the flash, a long tunnel, leading back.

Your coming of age. It is early. From your bed you watch your mama moving back and forth under the light. The bells of the church ring in the dark. Mama crosses herself. From your bed you watch her back as she wraps the things you will take.

You are sixteen. Your father has sent for you. That's what it means: He has sent an address in Nevada. He is there with your uncle. You remember your uncle remembering snow with his beer.

You dress in the shadows. You move toward the table, the circle of light. You sit down. You force yourself to eat. Mama stands over you to make the sign of the cross on your forehead with her thumb. You are a man. You smile. She puts the bag of food in your hands. She says she has told *La Virgin*.

Then you are gone. It is gray. You hear a little breeze. It is the rustle of your old black *Dueña*, the dog, taking her short-cuts through the weeds, crazy *Dueña*, her pads on the dust. She is following you.

You pass the houses of the village, each window is a proper name. You pass the store. The bar. The lighted window of the clinic where the pale medical student from Monterrey lives alone and reads his book full of sores late into the night.

You want to be a man. You have the directions in your pocket: an address in Tijuana, and a map with a yellow line that leads from the highway to an "X" on a street in Reno. You are afraid, but you have never seen snow.

You are just beyond the cemetery. The breeze has died. You turn and throw a rock back at *La Dueña*, where you know she is—where you will always know where she is. She will not go past the cemetery. She will turn in circles like a *loca* and bite herself.

The dust takes on gravel, the path becomes a rutted road which leads to the highway. You walk north. The sky has turned white overhead. Insects click in the fields. In time, there will be a bus.

I will send for you or I will come home rich.

Mexico

We have our lands, pure rocks.
They don't produce anything.
Crops barely grow. We have to go
to the U.S. to have something
better for our families. We send
money, well some of us do. The
family that receives money lives
peacefully. They say, ''My husband
sends me money. I'm going to buy
some animals to breed more ani-
mals.'' When we go home, we go
with much love, much happiness,
and we're close to the family.
We're together for a while. But
when the money finishes, we have
to come North again. That's what
happens.

—Carlos R., 30,
San Juan Mixtepec, Oaxaca

Outskirts of Morelia, Michoacán.

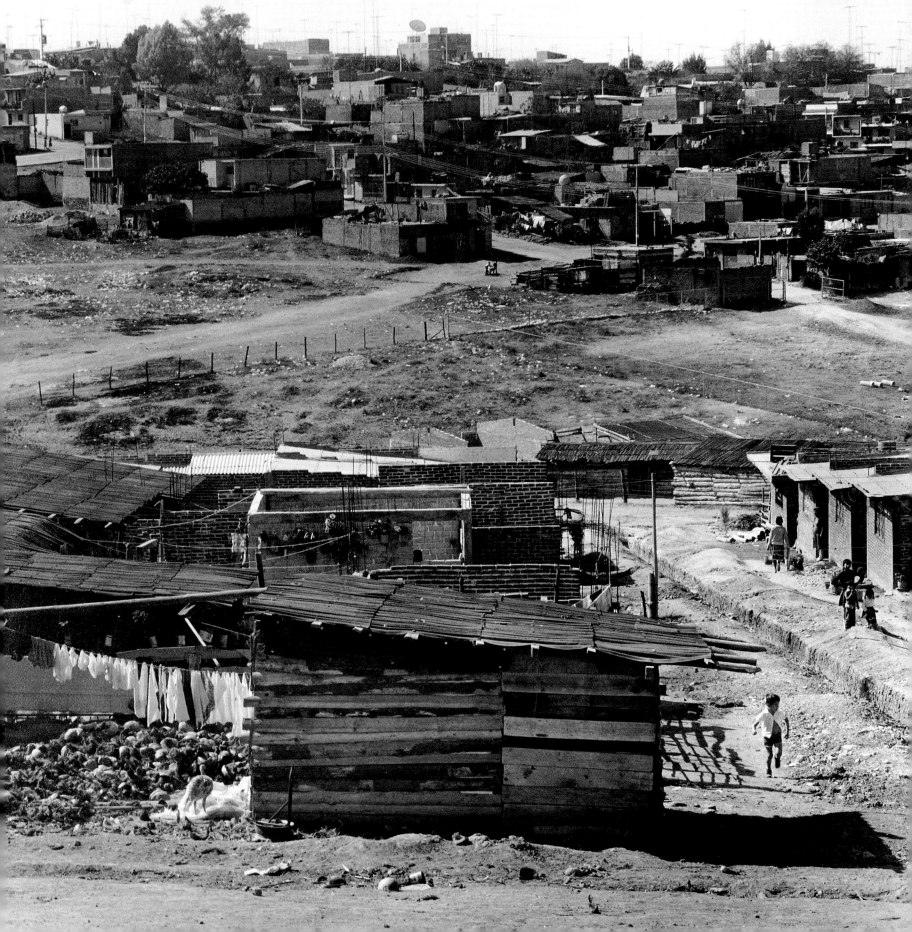

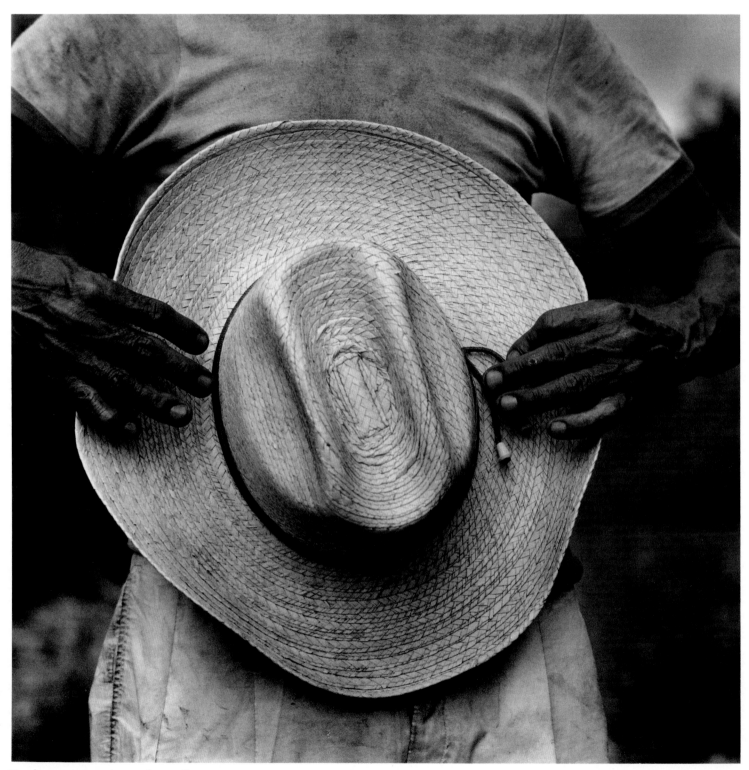

Handwoven *campesino* sombrero, Oaxaca.

I. San Jeronimo, Mexico

by Mary Jo McConahay

There is a town on the downhill side of a rutted track deep in the mountains of Oaxaca that appears to be at the end of the earth. The road leading to it goes no farther. Surrounding slopes are dry and cracked. The only sharp colors are provided by two lonely blue church domes rising over brown roofs and dusty streets. San Jeronimo Progresso is home to nearly 1,500 Mixtec-speaking Indians. Otherwise, it is typical of hundreds—perhaps thousands—of villages in western Mexico whose residents follow the migrant labor trails to the farms, ranches, and homes of the United States.

Studying this small town in the late 1970s, a team of anthropologists found that without migration San Jeronimo Progresso could not support more than 250 people. They noted that on its poor, unirrigated soil, the average household of 8.8 people needs 9.9 acres of land to produce the 2,750 lbs. of corn it needs to consume each year. But the average holding is 3 acres, and the average cultivated land per household is only 1.8

It's been several years since I have gone back to the place I'm from. But I still have the illusion that everything is the same. And that I always remember.

—Emilio N., 23, Guanajuato

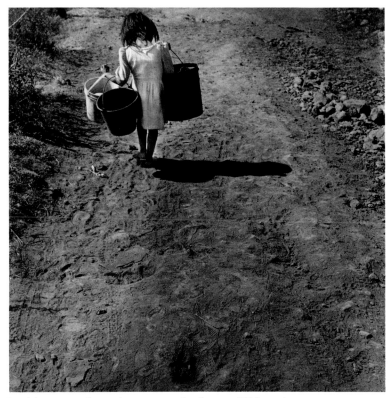

Fetching water from the community faucet, Michoacán.

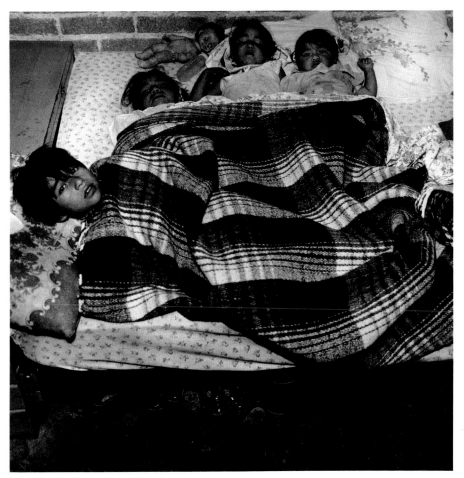

Juan Soriano's children, Tequixtepec, Oaxaca.

acres. Because of these stark conditions it is not likely the exodus will be reversed. A Mexican government report published in the early 1980s said the Sierra Mixteco, or Mixtec mountains, where San Jeronimo sits at an altitude of 6,000 feet, has become so eroded it will be "no more than an arid steppe" in 30 years.

When I visited recently, it was apparent some things had not changed. Men, women, and children arrived in town at various hours of the day bent double under loads of firewood gathered from out of the mountains to sell. As residents chatted, rested, and even as they walked, many worked straw with their hands to make hats that might sell in bigger towns on market day. Aside from the selling of wood and hats, which brings in pennies, there are not many jobs available to families whose land is not enough to feed them. Because only 9 families already monopolize the village's commerce as storekeepers, moneylenders, and truckers, even starting a little business is not an option. The one new source of local employment is construction of the modest city hall and houses built with money sent back by workers in the United States.

Blood, tears, and cash remittances connect San Jeronimo Progresso to the swollen barrios of Tijuana, to San Diego County, Riverside, Fresno, Santa Rosa, and other points in the North where its sons and daughters live and work. According to a 1981 study by Michael Kearney and James Stuart, 85 percent of San Jeronimo's men over the age of 15 had left the village at least once searching for work elsewhere in Mexico and the United States. "It doesn't matter how bad things are for us in Tijuana or California," one resident told me. "If we stay here we will only be waiting to starve."

Mexicans from other regions have gone laboring *al norte* out of hope and necessity for decades, but Indians from Oaxaca, Mexico's poorest state, only began traveling north in the 1970s. The birth rate in the Sierra Mixteco is one of the highest in Mexico, but the region is dying fast. A drought which has lasted almost a decade has only exacerbated the migration. Lorenzo Garcia, who has lived here all his 62 years, called it "the worst I've ever seen."

Government figures show that only 3 out of 10 Mixtec Indians now live in the mountains on a permanent basis. They by-

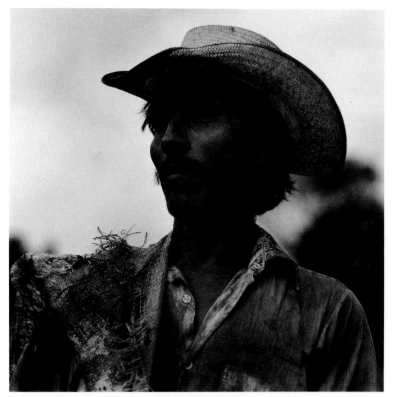

Mother and daughter washing clothes for the new year, Oaxaca.

Sugar mill worker, Constancia del Rosario, Oaxaca.

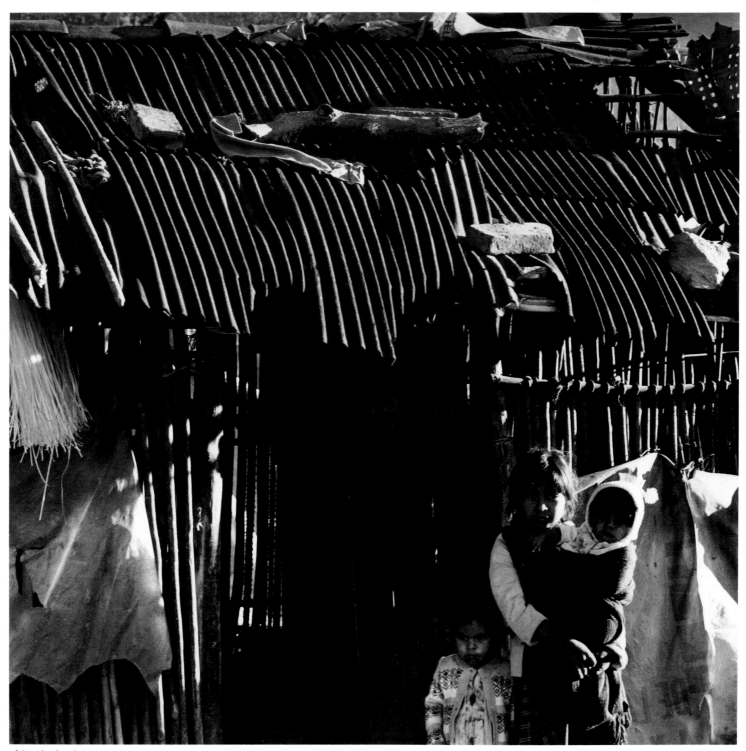

El jacal (shack), Cuyotepeji, Oaxaca.

pass the overcrowded "misery belt" around Mexico City, where they feel jobs are scarce, and travel directly to the border area. There they huddle together, creating virtual satellites of their home villages and using them as launching pads into the United States.

Garcia's son Mauricio, 19, said he is planning his third journey north because "here there are no jobs at all." His wife Magdalena, 18, wants to leave too, but Mauricio argues that she should wait until their infant daughter is older. In response, Magdalena reminds him that increasing numbers of women neighbors are now migrating along with their husbands, sometimes bringing children.

"Besides, it's easier to work in the fields when the baby is very small than when she's old enough to move around by herself and get into trouble. And who knows," she added shyly, wistfully, "if God wills it, maybe I'll even find work in a house."

Kearney and Stuart found that over half of San Jeronimo's women over 15 migrated with their husbands, more often to points farther north in Mexico, but also to California. The men dream of working their way out of the back-breaking row crops and into the tree crops; the women aspire to working their way out of the fields altogether and into jobs as domestic servants. In 'the U.S. border towns they may be paid only meals and bus fares, but Magdalena and her friends told me they take encouragement from reports of women who make as much as $100 a week cleaning houses for white families in California.

Later, as I sat talking with Lorenzo Garcia at the single wooden table in his dark house, Mauricio arrived with Magdalena and three of his brothers with their wives. Silently and respectfully, they took places on the dirt floor. There they shared a midday meal of thin, peppery soup and beans. When they spoke briefly among themselves it was not in Spanish, but in Mixtec. "It is unusual to have all of them here at the same time," said Garcia, looking over his family. "Soon they will be leaving again for the North."

Thanks to jobs in the North, over the last 15 years townspeople have built a new road, which in turn led to installing electric lines, a water system, and a new school. Yet few able-bodied men or boys are seen on the streets because so many have gone elsewhere to look for work.

Away from home many still maintain their traditions, a fact which may help them to survive on the alien trail. As they have done since the time before Columbus, residents of these Mixtec villages continue to own land communally (which keeps outsiders out), and marry within their own village. Each community shares special religious-type ceremonies and a way of speaking their Indian tongue which may be different even from

More than anything, I miss the customs, simply the warmth of the family. Being far away from home, you find yourself with no one to lend you a hand. If you have a problem, well, you solve it alone. You have no one to share it with. But over there when something was wrong, I would tell my mother or my brothers.

—Narciso P., 36, Michoacán

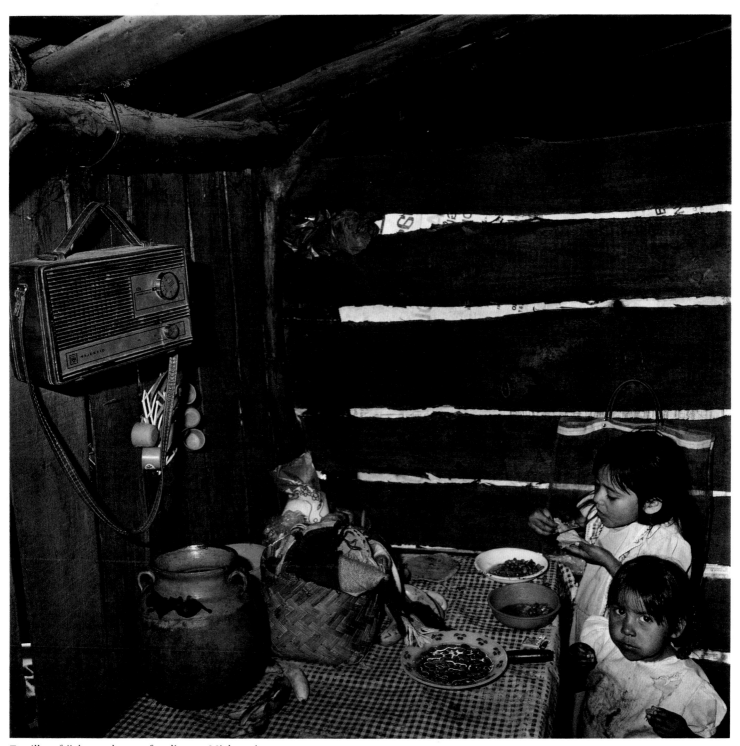

Tortillas, *frijoles*, and *queso* for dinner, Michoacán.

that of the village next door. Rather than breaking down under the pressure of distance from home, the ties that bind the migrating Indians together may actually grow stronger.

Wherever they go, Indians from San Jeronimo seek out other villagers who have preceded them along the trail, stay under their roofs, and find jobs with the same bosses. "As economic survival becomes more precarious, these personal relations become more important," Kearney told me. Fifteen hundred miles north, for instance, hidden in the scored hills near the U.S. border, is a collection of shacks connected by steep dirt paths that is home—for now—to Indians from San Jeronimo and other distant villages. The *Colonia Obrera* (workers' colony) feels densely populated. But tucked into canyons behind a rise of brown earth, it is invisible to American tourists speeding toward beach resorts on an adjacent tollroad.

"I came in 1970, one of the first to arrive from San Jeronimo," said 40-year-old Jorge Gonzales when I arrived at his house. "Now you see how many we are," he added as he swept his arm toward hundreds of houses, constructed from scrap materials, clinging precariously to hillsides. Inside the house, shafts of sunlight came through cracks between boards and crossed the dirt floor. Two teenage daughters sat in a cramped room caring for younger children and watching television. Gonzales's wife Maria, 38, was nursing a newborn. She was proud to say she was one of the squatters who had "fought hard" to convince authorities that tanker trucks, the only source of water, should make deliveries to the colony. "They like to ignore us here, just like the government ignored us at home," she said. "You only get help if you can help yourselves."

Gonzales said he crosses *la linea* with consistent success, but regularly returns to the Mexican side of the border to be with his family.

In another corner of *Colonia Obrera* I watched four young Mixtec men shoring up a steep dirt slope with discarded tires, a common method of terracing here to prevent dangerous landslides. They switched from speaking Mixtec to Spanish for my benefit. "We've been as far as the apples in Santa Rosa," said the least shy of the young men. "But the next time I make it across the line I'm going to stay. I have come this far already. To remain on this side means getting paid like a slave."

(Continued on page 68.)

In our town we are poor. We have no riches, no way to produce on the land. We have nothing to teach each other. We are very poor, very low. Of course, we are wealthy, but we don't know that.

—Carlos R., 30,
San Juan Mixtepec, Oaxaca

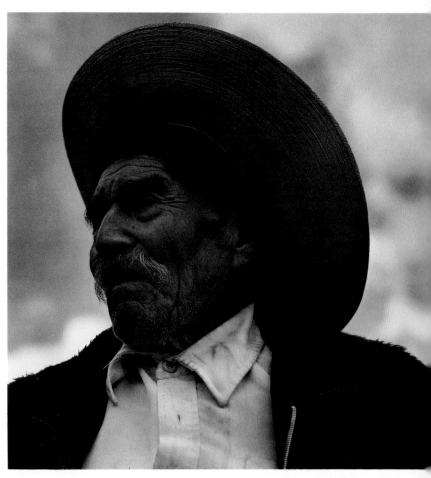

Compadre Señor Lupe, Suchitepec, Oaxaca.

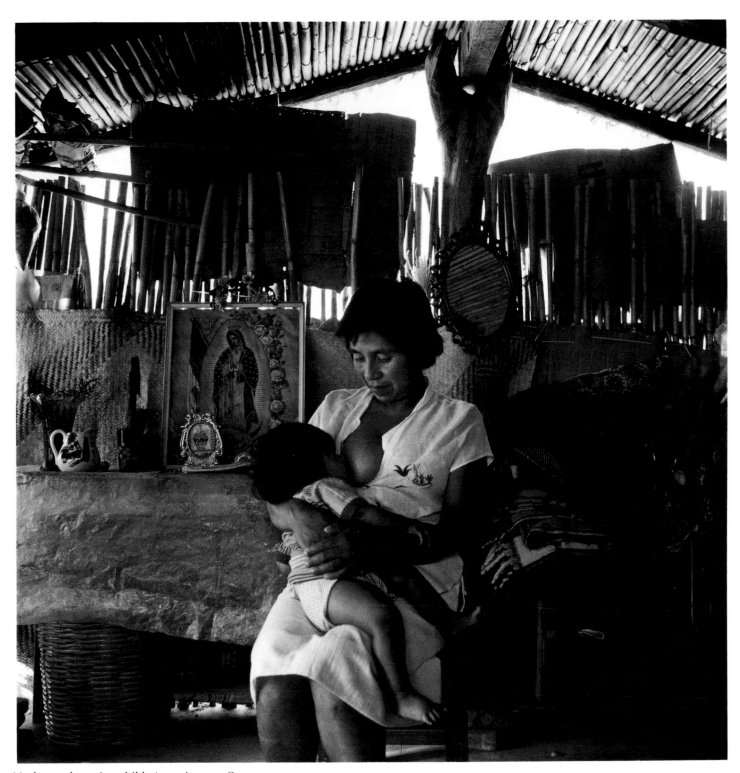

Mother and nursing child, Acaquizapan, Oaxaca.

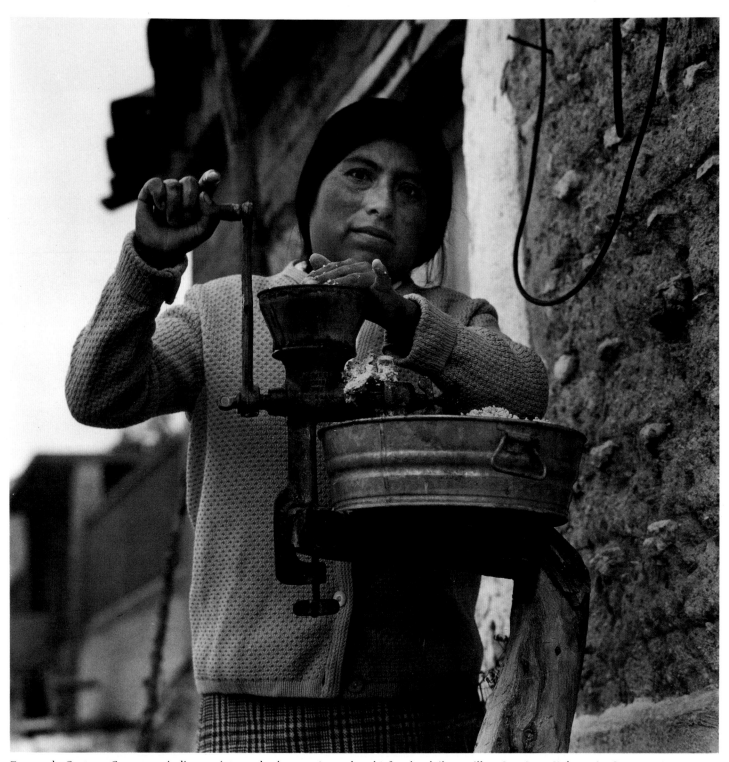

Esposa de Gustavo Guzman grinding *maíz* to make *la masa* (corn dough) for the daily tortillas, San Juan Yolotepec, Oaxaca.

The life of the people is very mono-
tonous to a certain degree. But
also very agreeable, because you
have a rhythm of life.

—Fernando G., 30, Nayarit

I used to work for another person,
plant corn, harvest, clean corn,
move dirt, all of that. But always
there was bad treatment and little
pay. That's why I decided to come
to the U.S.

—Alfredo V., 25, Morelos

I had it in mind to buy a tractor
with the money I would earn,
machinery to work our land, my
father's land. To do a lot of things
we didn't do because of the lack of
machinery. More than anything
that's what made me come to the
U.S.

—Emilio N., 23, Guanajuato

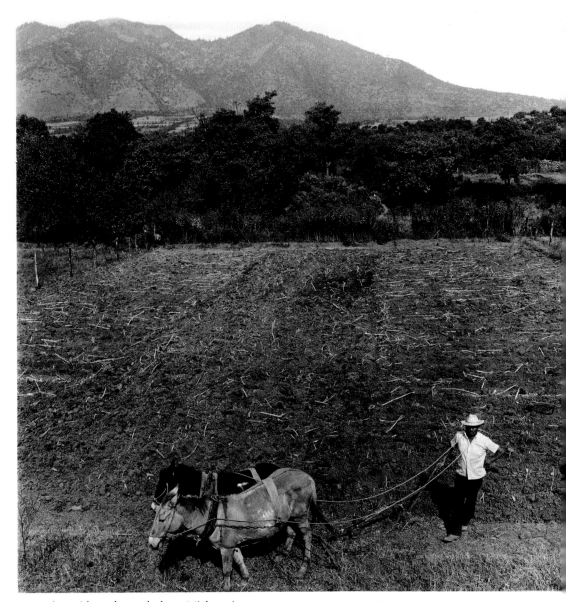

Campesino with mules and plow, Michoacán.

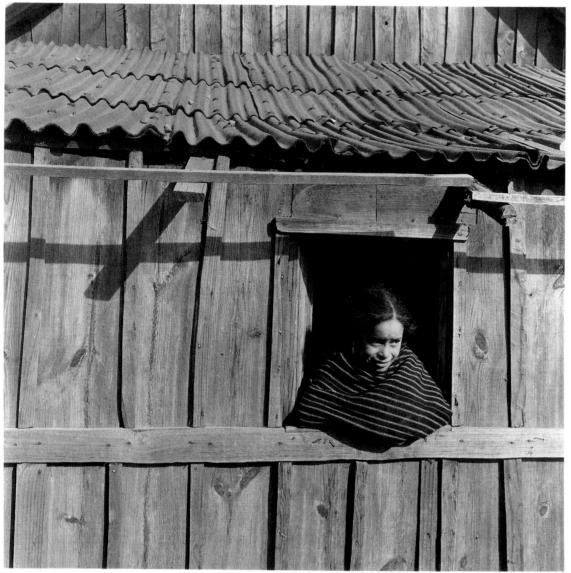

Young woman wearing a *rebozo,* Michoacán.

The women have no say. The parents decide who they will marry. That's how the marriage is set up. Then there is a huge fiesta. They kill two cows, one for each house, and the fiesta lasts three nights and two days. A wedding.
 —Leonor R., 23, Tepejillo, Oaxaca

La novia (bride), Tequixtepec, Oaxaca.

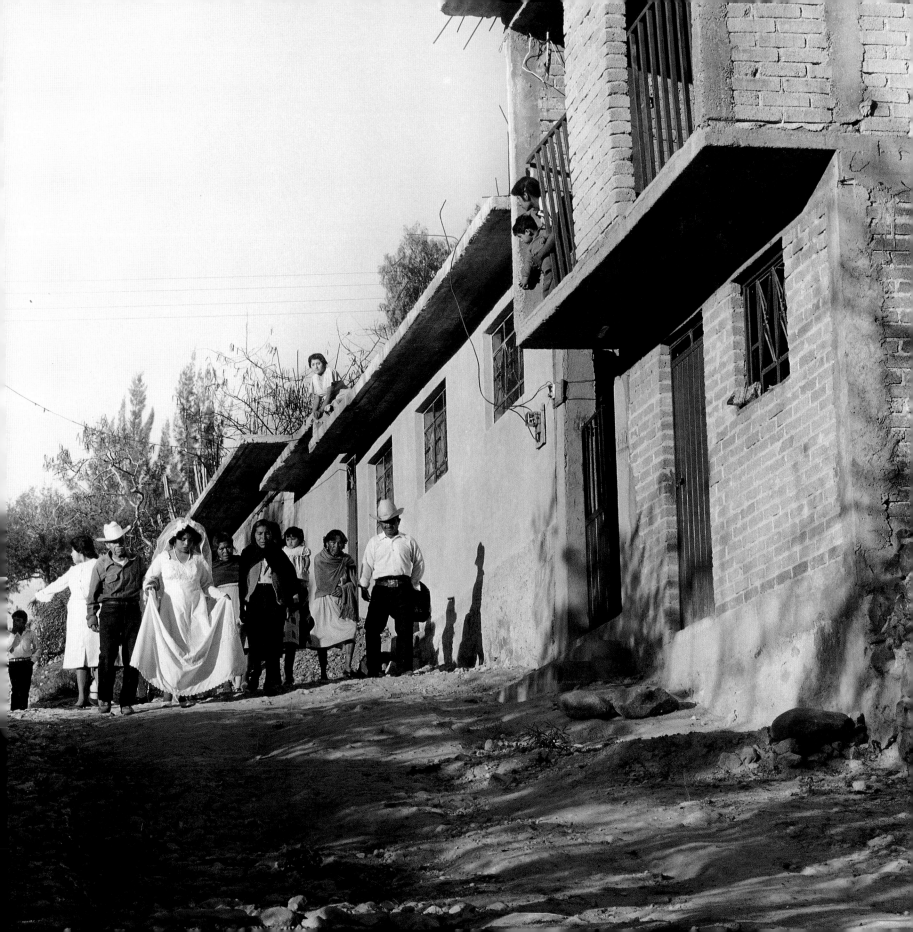

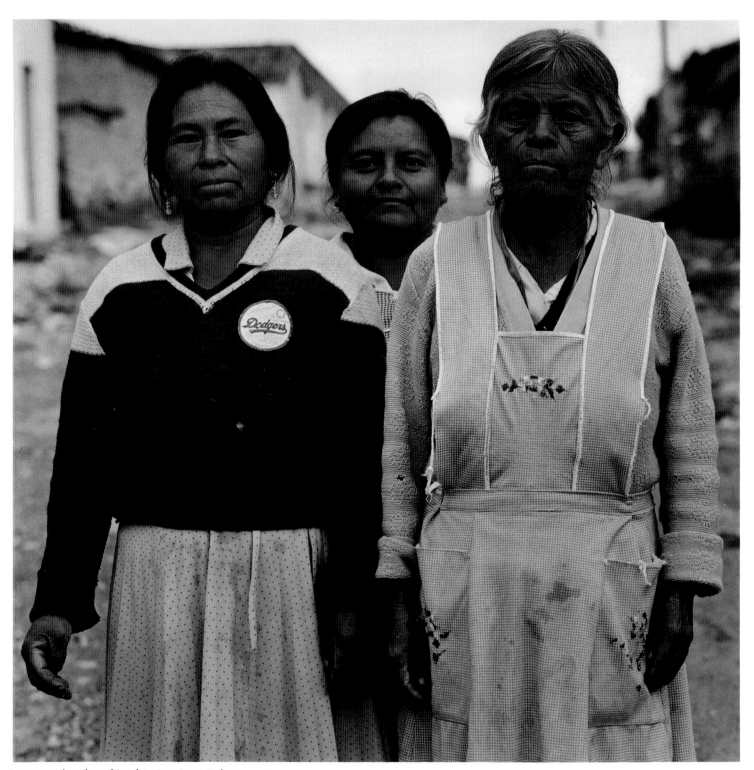

Las campadres (best friends), San Juan Yolotepec, Oaxaca.

What I remember most about my town is that I never went hungry, because of my mother. Because my mother washed and ironed for a living, we always had food. Never, never, I don't want to remember hunger, because I never knew what it was. I came to the U.S. to progress, to get ahead. And I'm going to do it, God willing.

—Florencio R., 31,
El Mochito, Guerrero

Mother and daughter with cross, Cuahutepec, Oaxaca.

*What do you most remember
about your homeland?
Our relatives. There's nothing else
besides our relatives.*

—Demetrio S., 34,
San Miguel Cuevas, Oaxaca

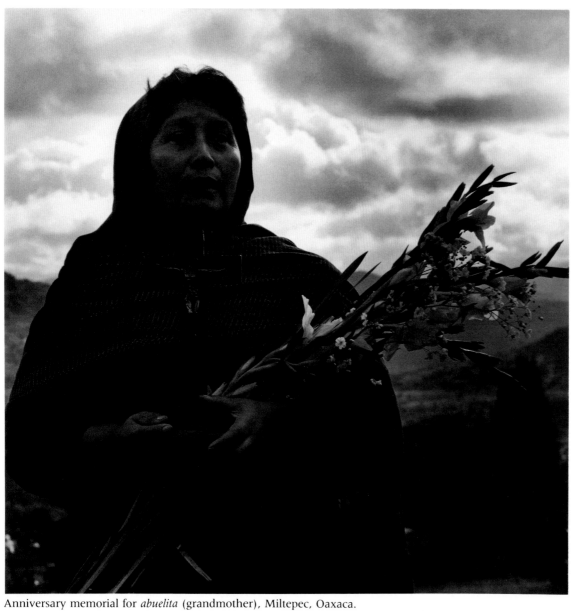

Anniversary memorial for *abuelita* (grandmother), Miltepec, Oaxaca.

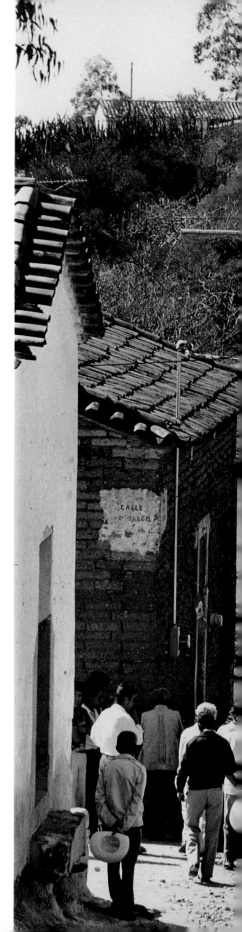

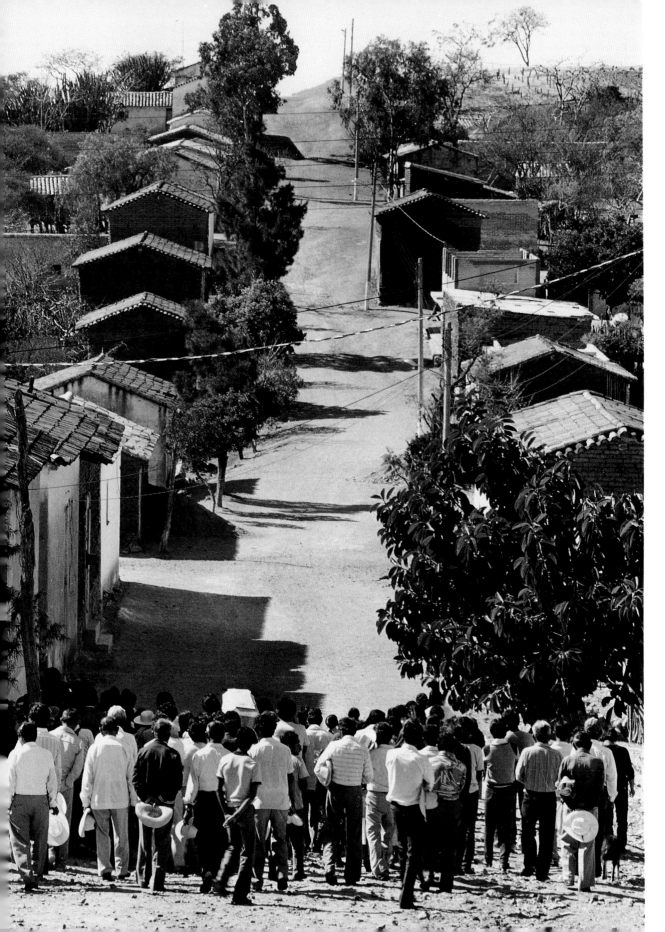

El entierro (funeral procession),
Acaquizopan, Oaxaca.

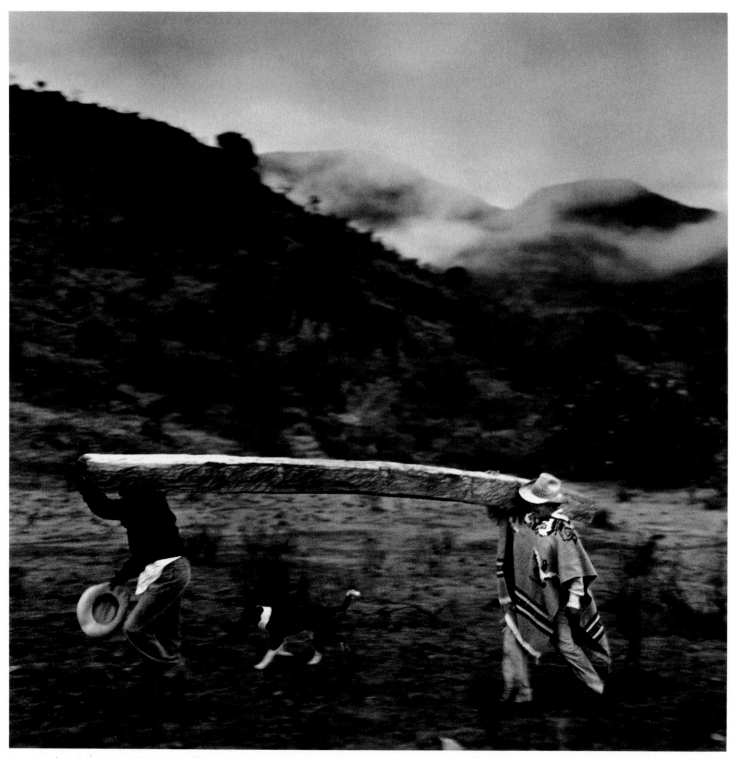

Carrying hand-hewn roof beam to Miltepec, sixteen kilometers from Cañada de Orcones, Oaxaca.

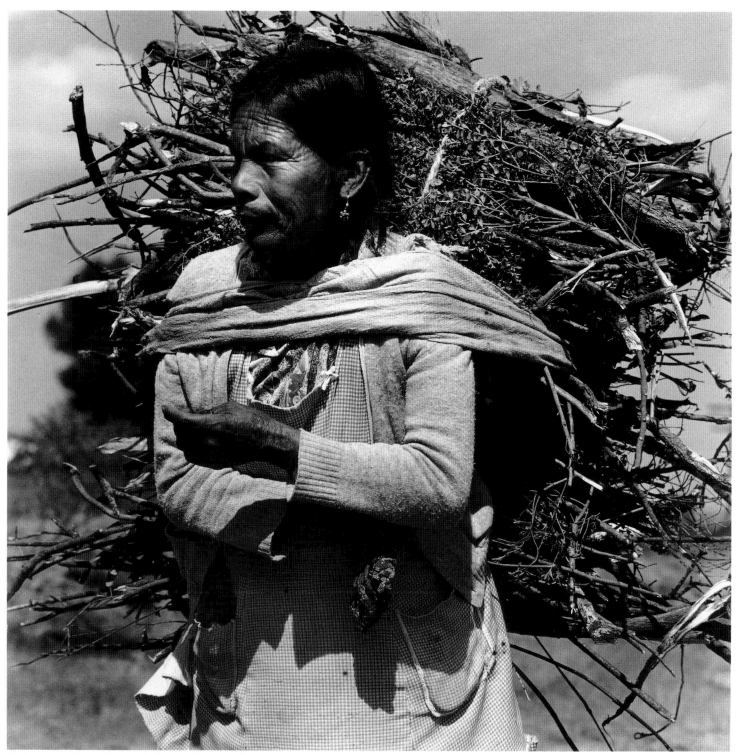

Gathering *la leña* (firewood) for cooking, Michoacán.

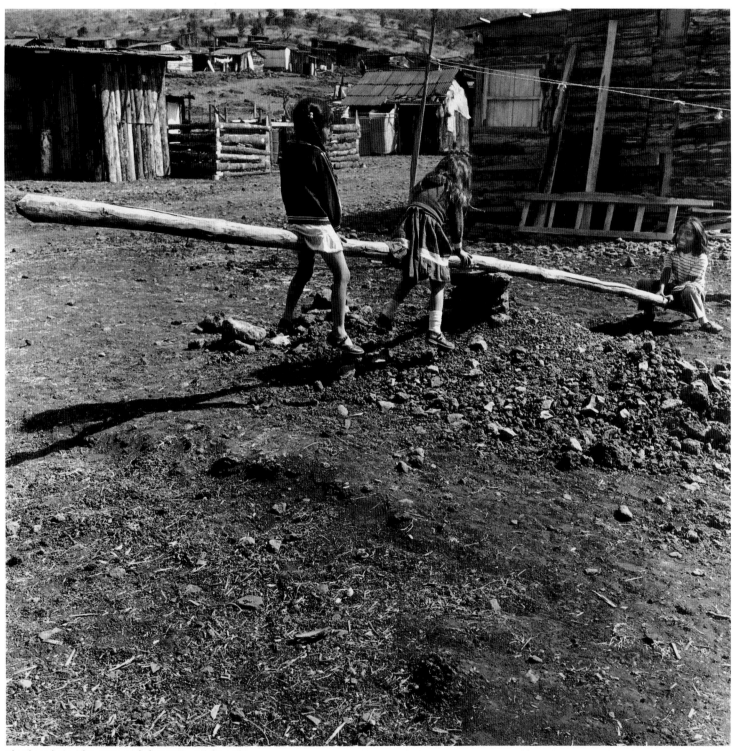

El sube y baja (the "up and down"), Michoacán.

If it doesn't rain, well, there is no harvest. That's when we get sad. We see our future generations, our own family. We have to support them and send them to school. I have mainly missed my family, because sometimes there is no communication. We write and sometimes the letters don't arrive. We feel bad for them. More than anything, I worry about how they are surviving economically. How are they living? That's why I return. If the situation is more or less normal, I come North again to look for work.

—Miguel M., 29,
Santa Cruz Mixtepec

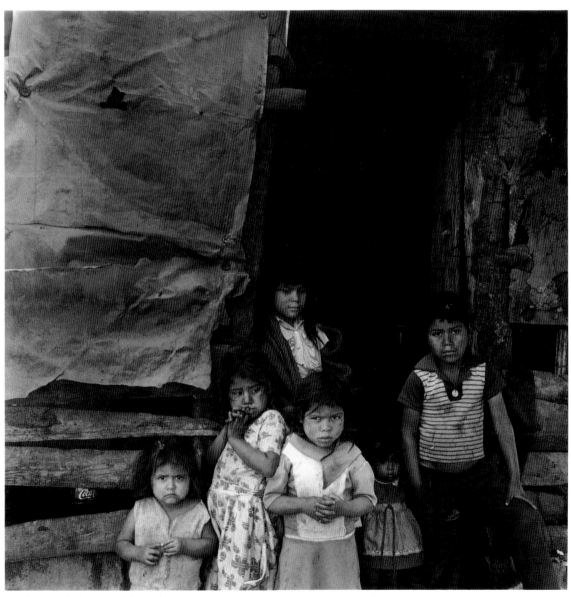

Brothers and sisters, Michoacán.

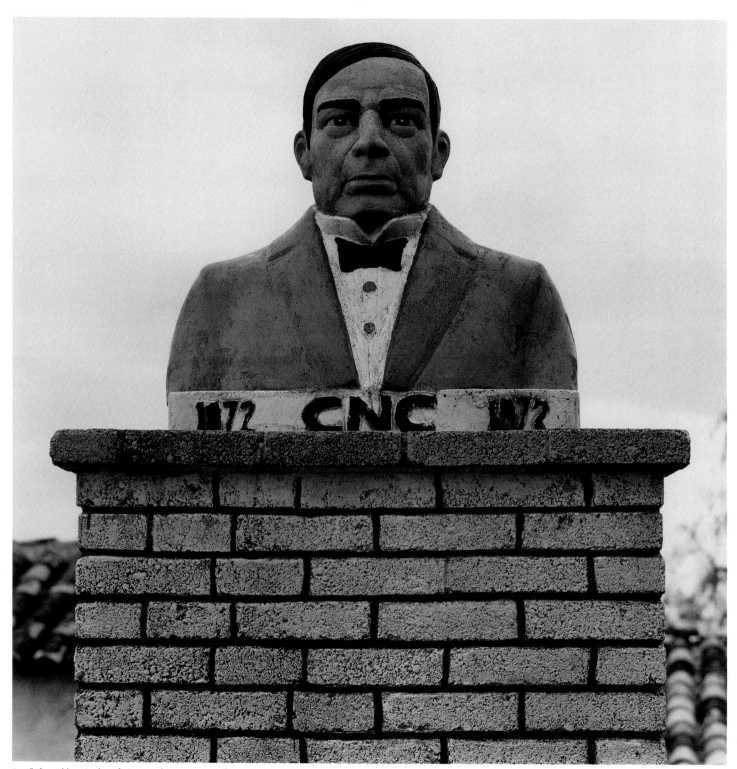

Confederación Nacional Campesina memorial to Benito Juárez, San Juan Yolotepec, Oaxaca.

The saddest and most painful thing is to remember that we have such a beautiful country rich in culture and traditions, but that it is a country in the hands of foreigners. In Mexico we have nothing, and that's because of our corrupt leaders.

—Pablo G., 29, Oaxaca

Whatever happens, we're Mexicans, and we should do all we can for our Mexico. More than anything, don't forget we're Mexicans. Unfortunately, there are a lot of Mexicans who have one, two, three, or five or more years here and already they feel like gringos.

—Emilio N., 23, Guanajuato

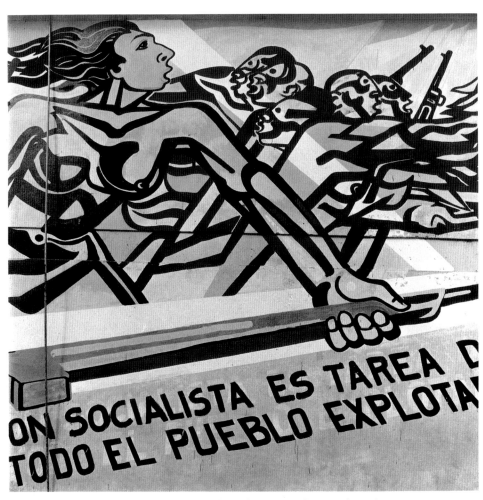

Mural: "Socialism is the homework of all exploited people," Michoacán.

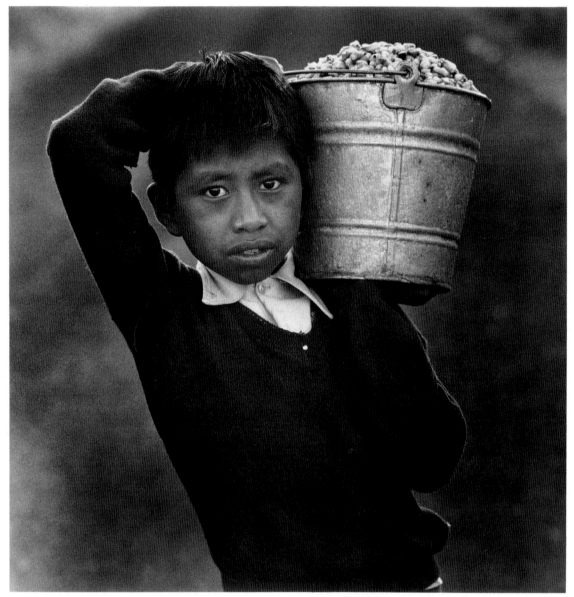

El nixtamal (cooked corn) to be ground at local mill, Tequixtepec, Oaxaca.

Over in my land, most boys around my age have the illusion. As they grow they say, ''I'm going to the North. I'm going to the North.'' When I was twelve years old the idea came alive in me.

—Antonio M., 23, Jalisco

34

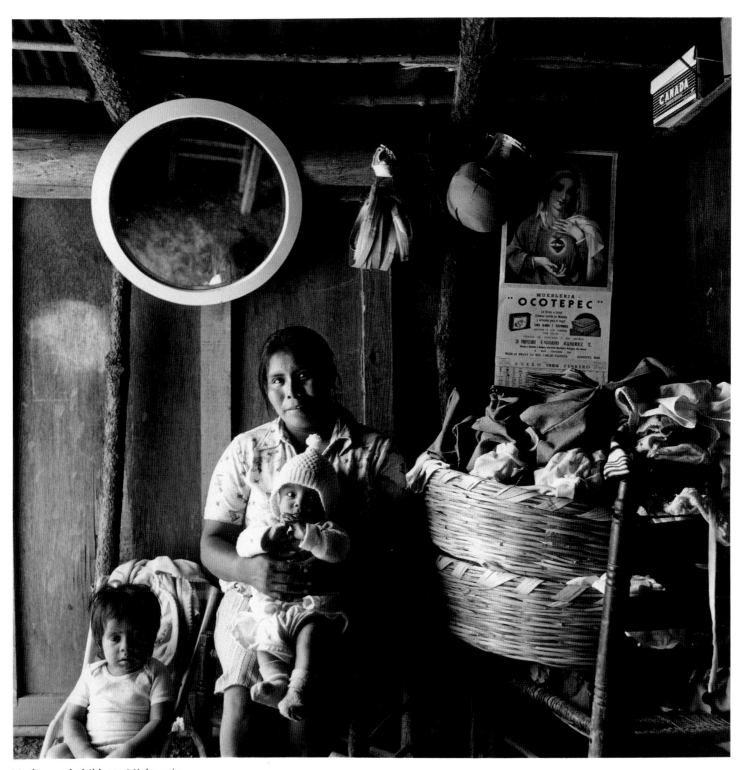

Mother and children, Michoacán.

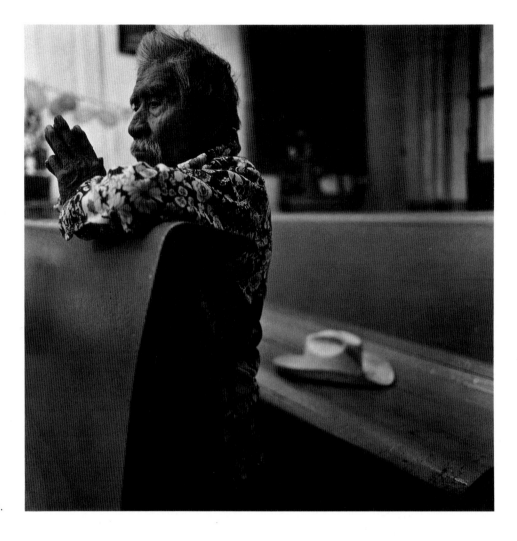

Señor Ilario Soriano, Tequixtepec, Oaxaca.

I want to return to Mexico more than anything else. There are more things to do over there for one's people. Especially during difficult times. You should be with your people when you are needed, don't you think? Struggle to have . . . Not for changing the world, *because sometimes that would be impossible, but to be with the needy and to make them aware of reality, not false dreams. Our people have been given a circus, somersault, and theater full of lies.*

—Pablo G., 29, Oaxaca

I have not seen my mother in ten years. I have seen my father and some of my brothers. We are a very big family, thirteen. I haven't seen more than half of them, and I hardly know some of them. I miss being with them.

—Narciso P., 36, Michoacán

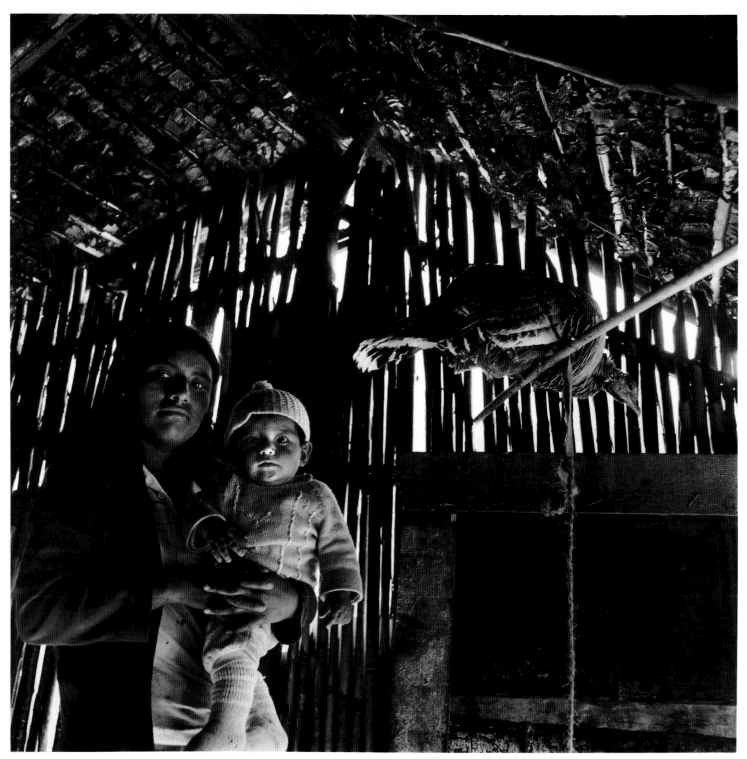

Woman, child, and *guajolota* (female turkey), Asunción Cuyotepeji, Oaxaca.

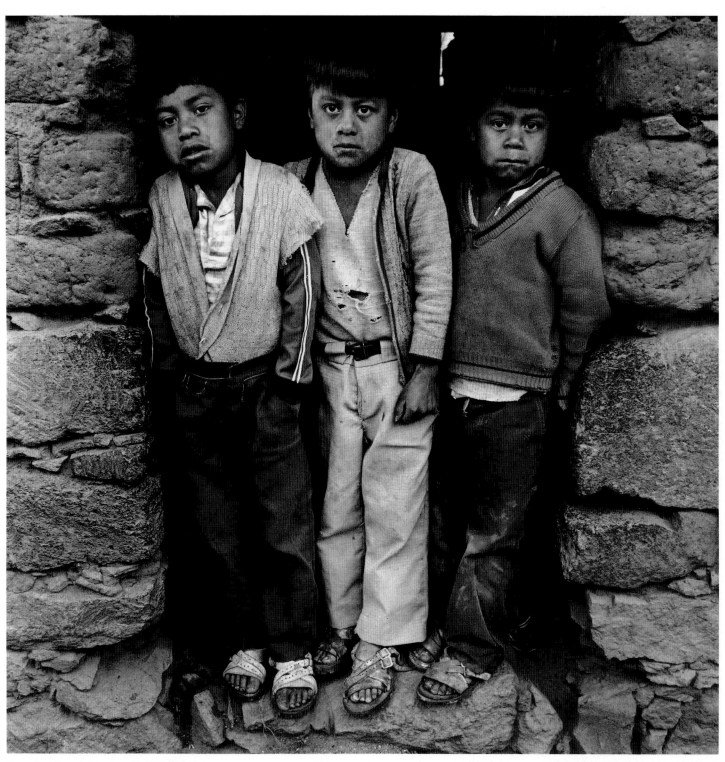

Three brothers, Cuyotepeji, Oaxaca.

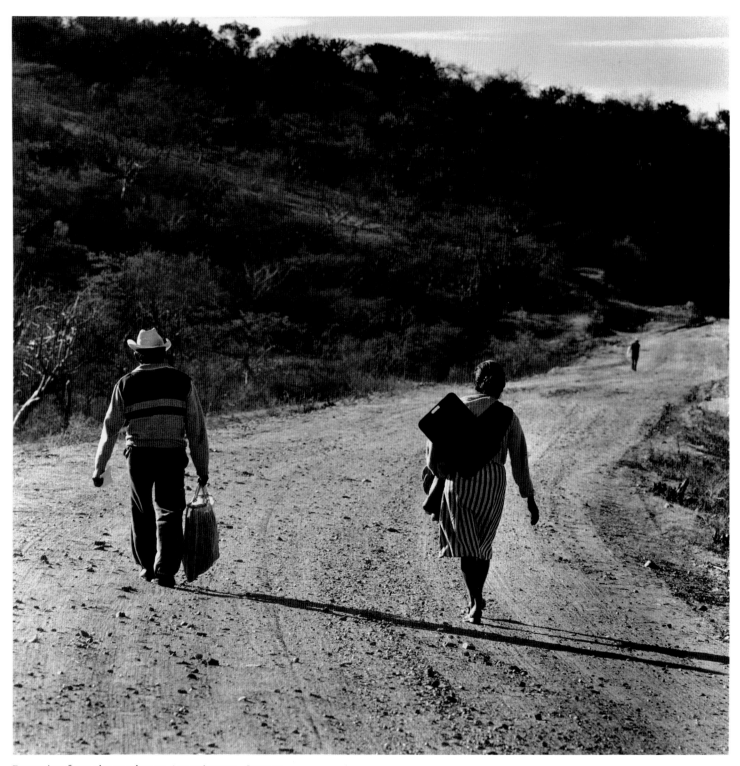

Returning from the market to Acaquizapan, Oaxaca.

La Frontera

*My aunt arrived in town, very
Americanized with her gringa hat,
putting the idea into our heads
that we can make dollars and
what are we doing in a little town
where there is no progress. Then
you say to yourself you must go
somewhere where you can make
it, see? You know, when you live
in a country town, a simple thing
like seeing a paved road seems like
a dream. I imagined a city like
that, like my aunt had described,
a city with trees.*

—Pablo G., 29, Oaxaca

Cañon Zapata/ "Soccer Field,"
Tijuana/San Ysidro.

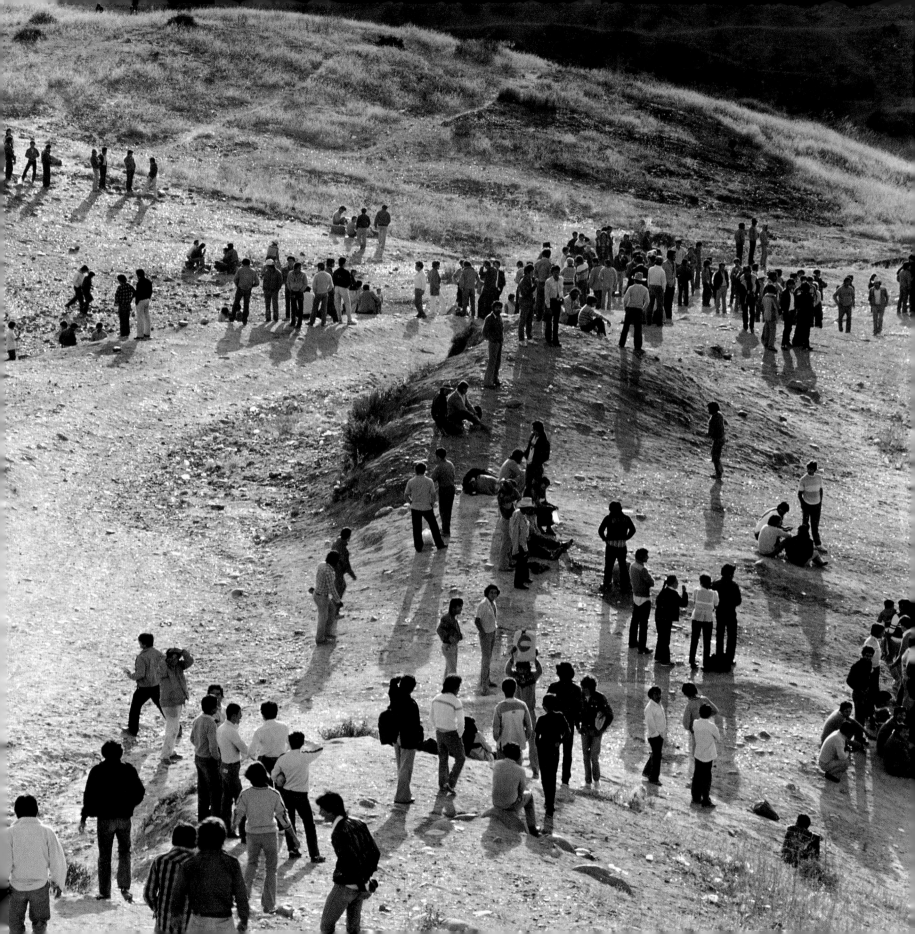

*I can only talk about the way I
came across. It was very difficult
for me. I'm not used to doing
that—run all night, hide, jump.
It's like the cat and the mouse,
with the fear of being caught.*

—Leonor R., 23, Tepejillo, Oaxaca

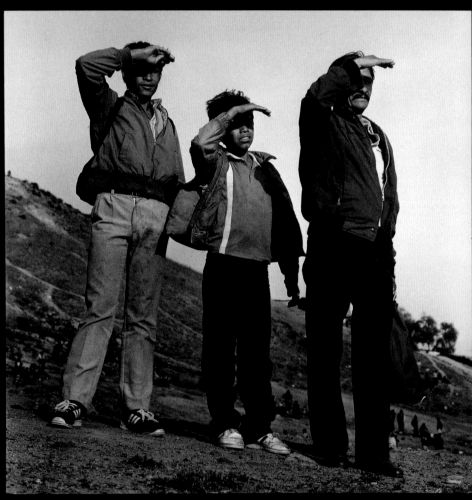

Father and his sons looking *al Norte* from Cañon Zapata.

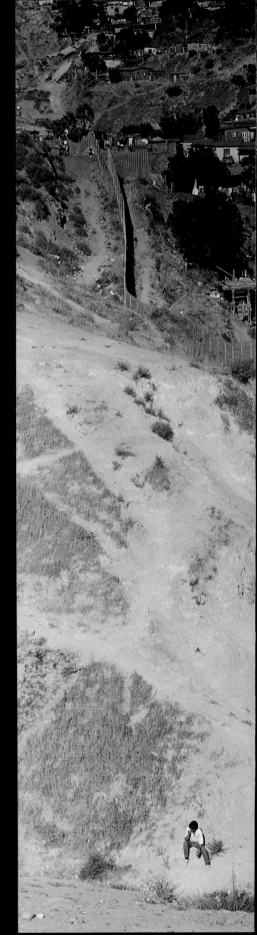

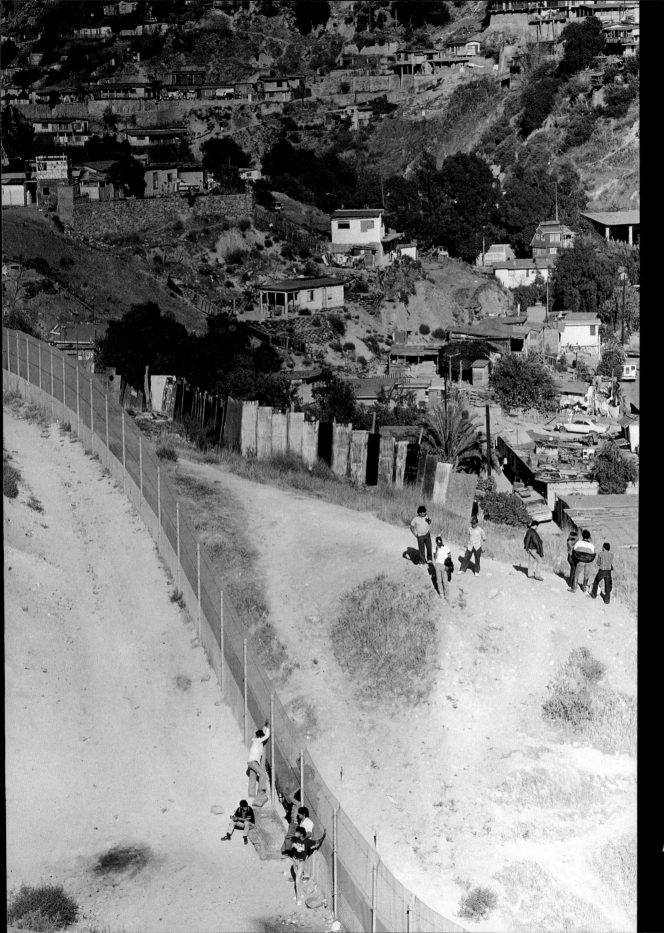

La línea (the line), U.S.-Mexican borde

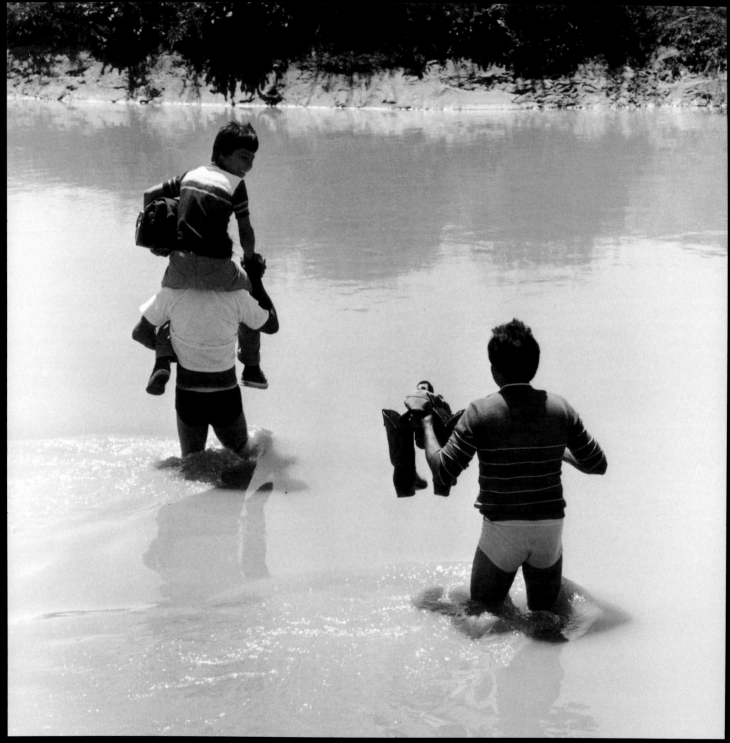

"Wetbacks" crossing the *Rio Bravo* (Rio Grande), El Paso, Texas.

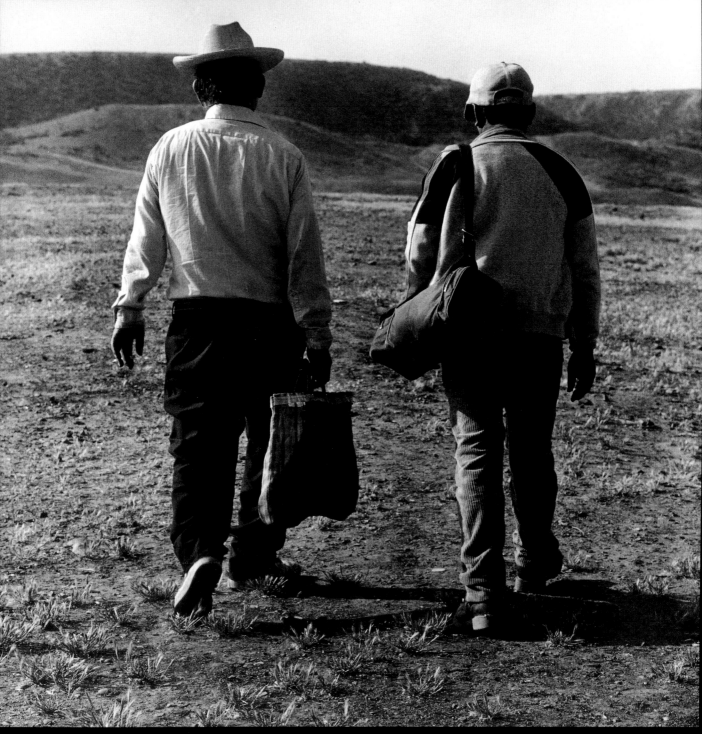

Leaving Cañon Zapata for *el Norte*.

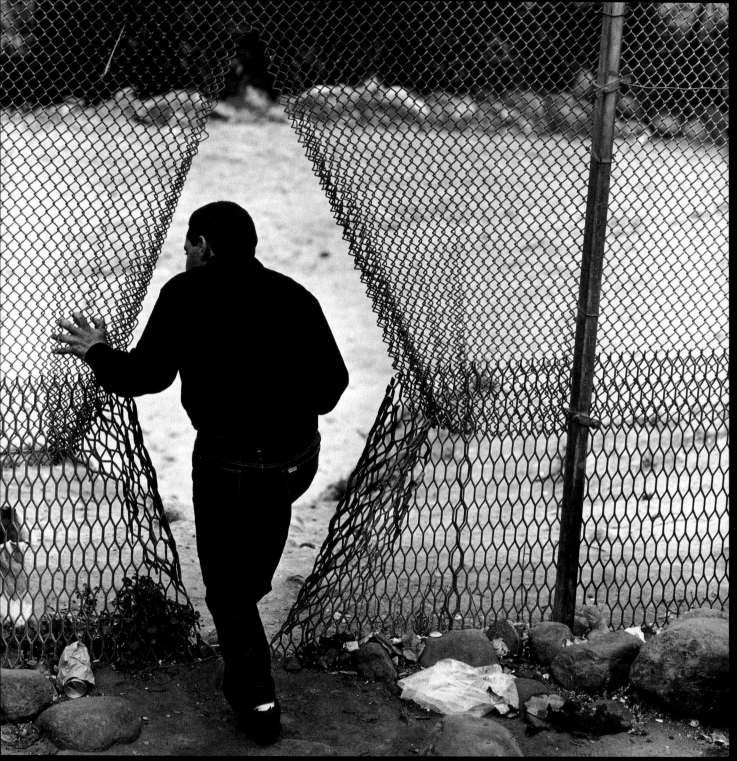

'El aqujero internacional'' (''the international hole''), Tijuana/San Ysidro.

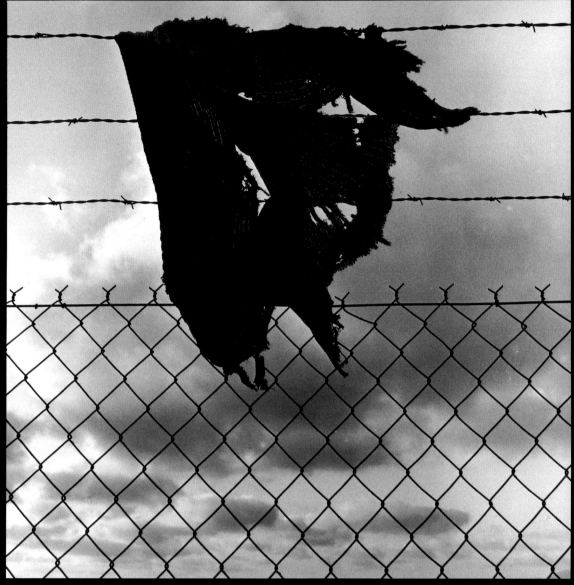

El sueter abandonado (abandoned sweater), fence along the border, Tijuana/San Ysidro.

When I left the state of Oaxaca I came to the state of Mexico and there, men from the state police check all those coming from the South and ask for papers. They want to know if we are really from Mexico or if we're lying. Even if we have documents, birth certificate, but we aren't carrying ID with a picture, they tell us: ''You're lying. Maybe you're from Guatemala or another state.'' Then they take us and ask for money. That's the bad part. They charge each of us about two or three thousand pesos.

—Simon S., 37,
San Juan Mixtepec, Oaxaca

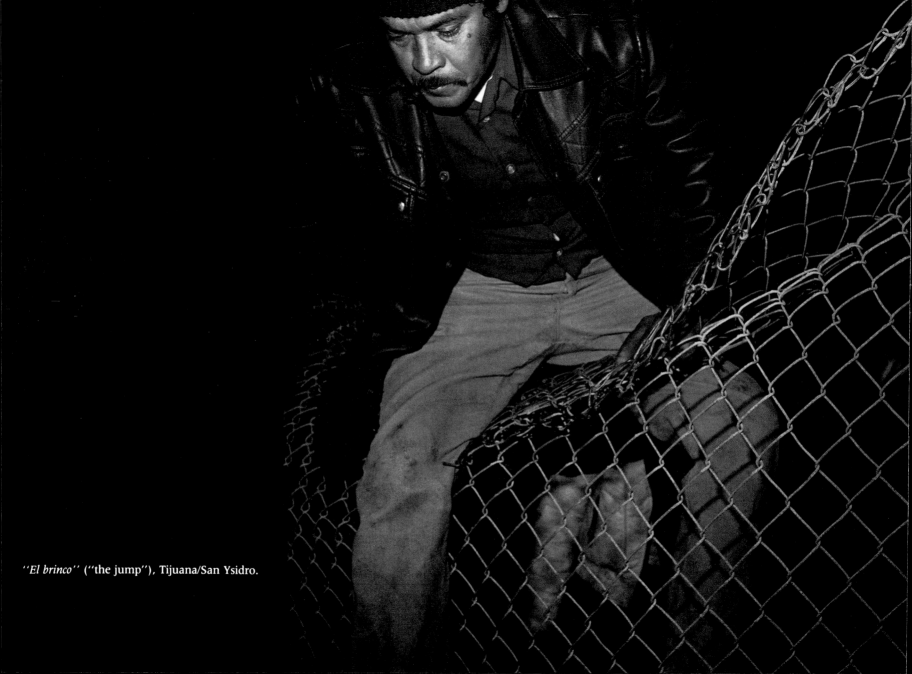

"El brinco" (''the jump''), Tijuana/San Ysidro.

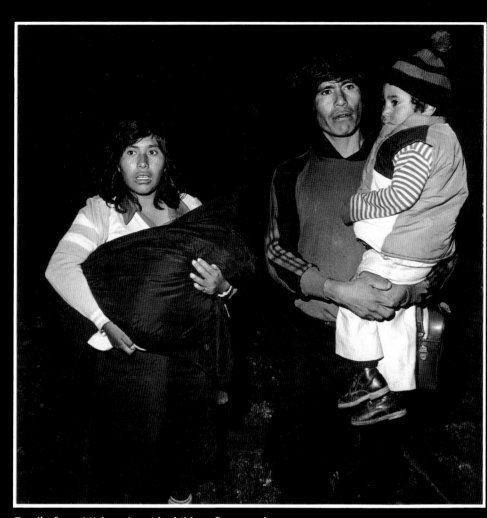

Family from Michoacán with children five months
and four years old apprehended in San Ysidro.

*Our first child was born here.
While we were expecting the sec-
ond child, la migra detained us
and sent us back to Mexico. We
had been in Mexico fifteen days
when our second child was born.
We returned six months later and
have not gone back since.*

—Narciso P., Michoacán

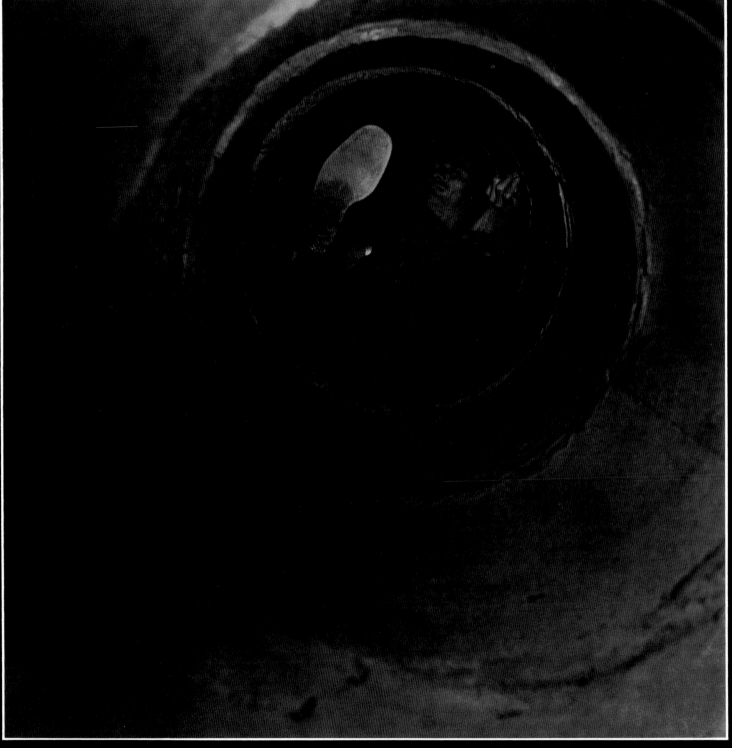

Crawling through the ''Oaxacan tube'' in San Ysidro.

knows what it is? Anyway, they got us there, they asked our names and different things, and they sent us back.

—Antonio M., 23, Jalisco

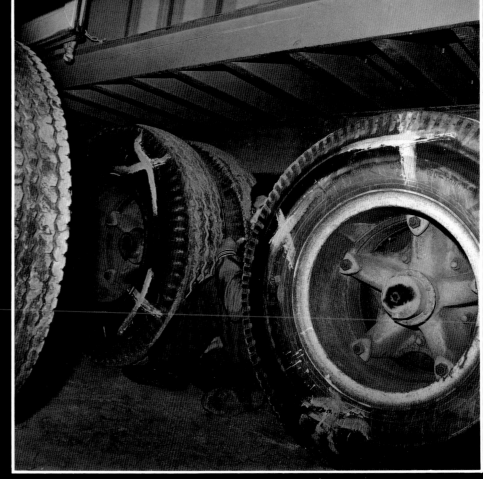

Hiding from *la migra*, truck storage yard, San Ysidro.

51

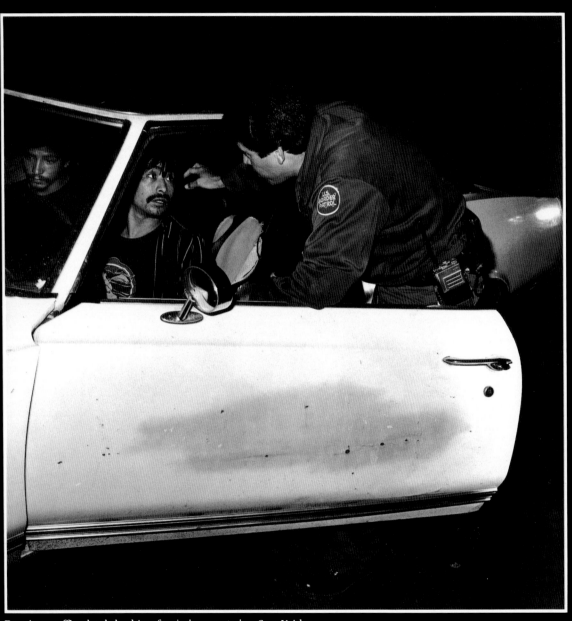

Routine traffic check looking for *indocumentados,* San Ysidro.

they say: ''It's our job, it's our duty to detain you. If it weren't for you we wouldn't have a job.'' There are others who treat you bad. One time we got caught crossing the hills. They got me too and kicked me. They were on horses, and they roped us as if we were animals. They took off our shoes. I don't know, maybe so we wouldn't run or something. They took off our shirts. Well, that's how they left us. Tied up in the middle of the hill while they went for others.

—Antonio M., 23, Jalisco

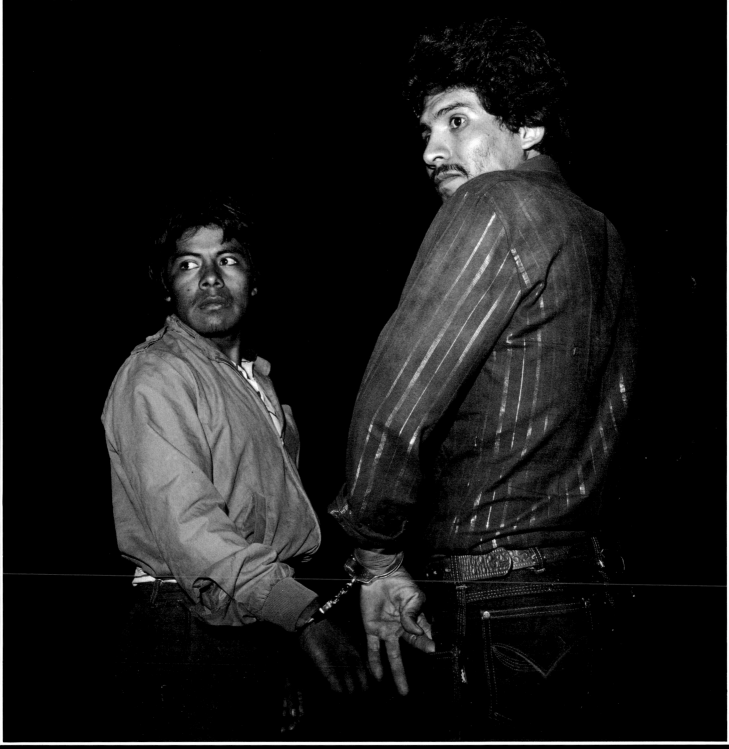

Los esposados (the handcuffed ones), San Ysidro.

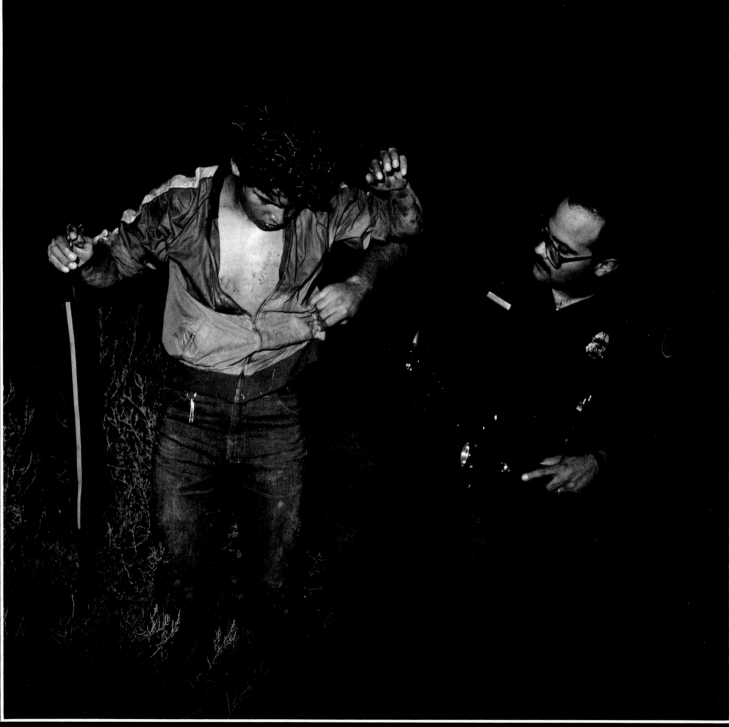

Apprehension, San Ysidro.

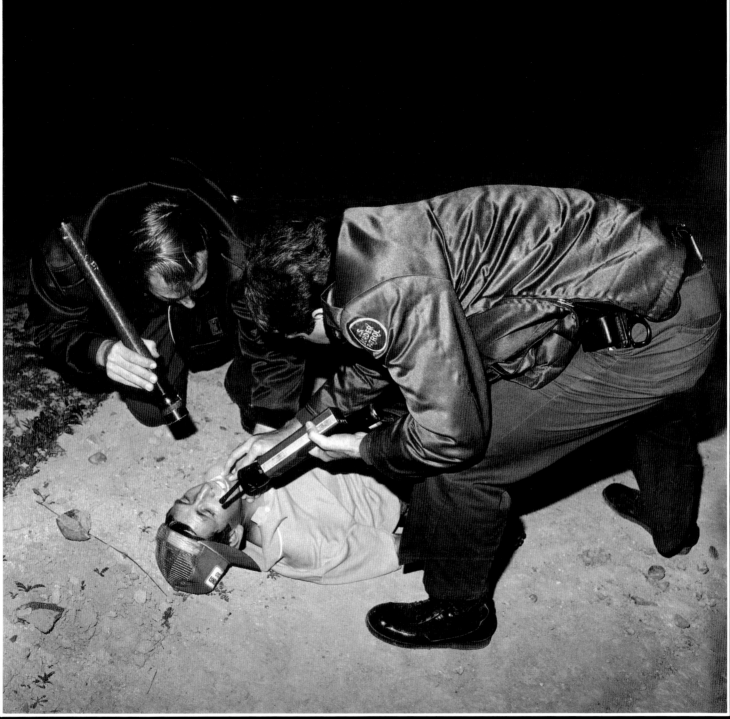

Victim of bandits, San Ysidro.

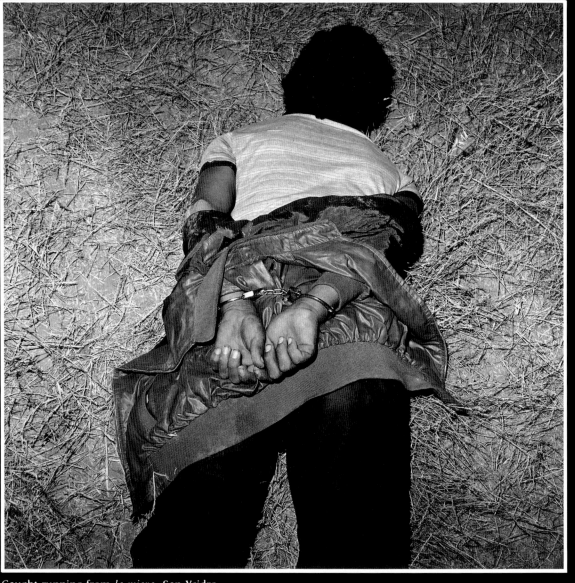

Caught running from *la migra,* San Ysidro.

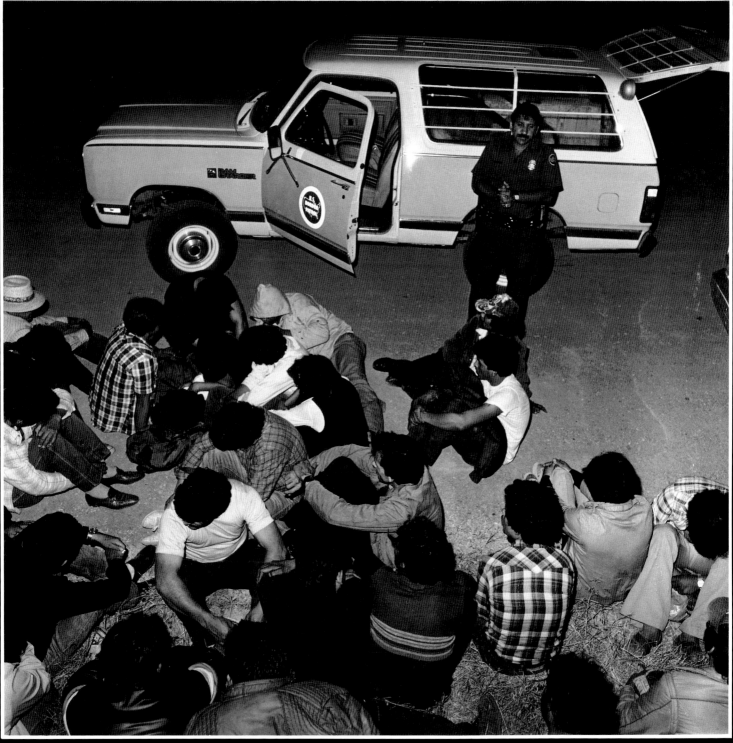

Border patrol agent with *"la perrera"* (*"van for the dogs"*) and men apprehended at *"Japs Drive,"* San Ysidro.

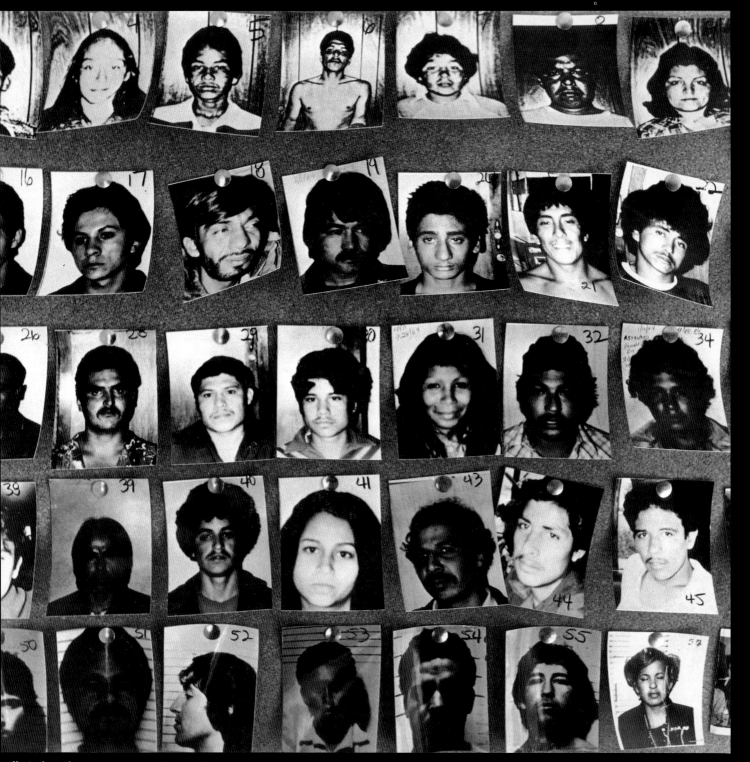

Bulletin board, Immigration and Naturalization Services (INS), *la migra,* San Ysidro.

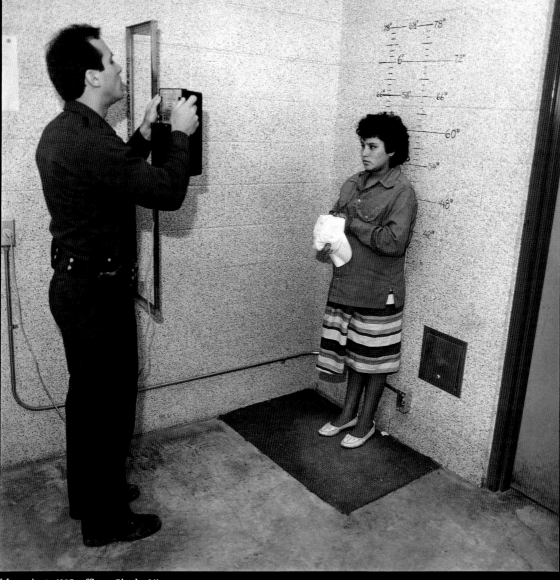

Mug shot, INS office, Chula Vista sector.

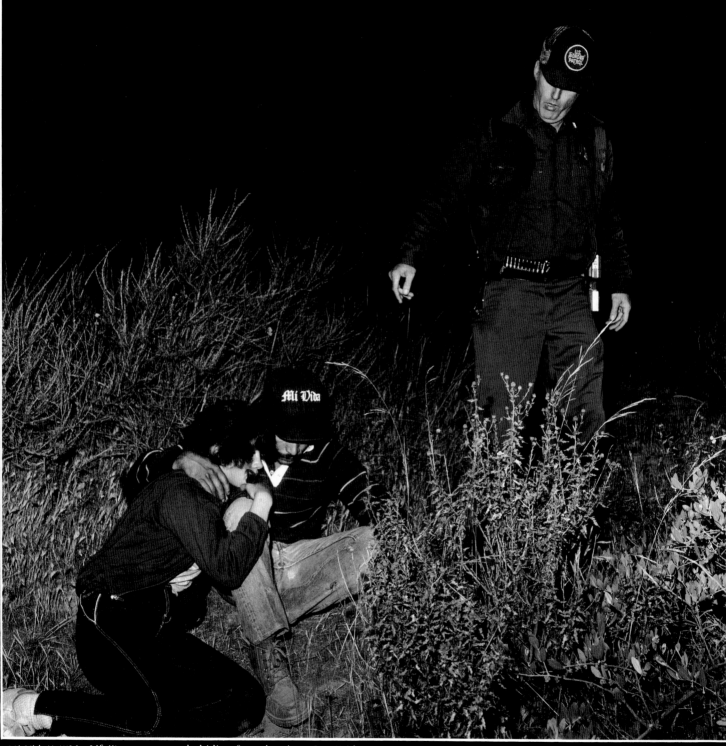

"Mi Vida" ("My Life"), young couple hiding from *la migra*, San Ysidro.

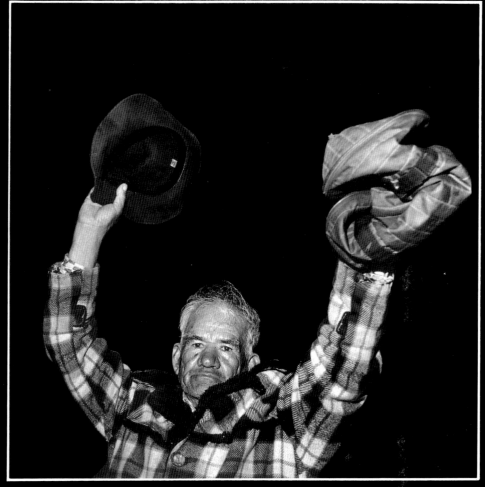

Surrender, 74-year-old man from Zamora, Michoacán; San Ysidro.

I just want to tell you what happened to me in 1982 in Arizona the second time I came. We were waiting for a coyote to bring us to California, and a person came up to us and said he knew someone who would give us a job. He said he would charge us $75 each to take us there. He had two small cars, and there were eleven of us, six in one car and four in the other. He took us out of the city and dumped us in the mountains. He didn't come back. We waited all the next day, but he never showed up. There was no food and no one to give us food. We had to walk for a long time to get to a road. We were very discouraged because we were in the woods and there was no one to tell us which way to go. But we were lucky and after three hours of walking we got to a road. We got a ride to Phoenix, Arizona, but we didn't find jobs there, and we had to sleep in the cotton fields.

—Filemon L., 31,
San Juan Mixtepec, Oaxaca

What impressed me most about the border was how dangerous it is. Once we tried to cross in a way that wasn't normal for the person who was bringing us. Without *regard for our lives. All thrown together in a van. The Border Patrol was chasing us, and the person who was bringing us didn't take our lives into account* *at all. He was driving very a narrow highway coming through Tecate.*

—Agustin P., 24

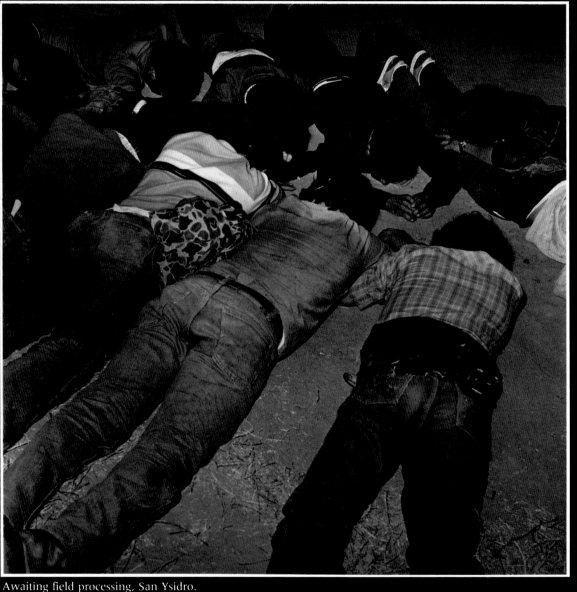

Awaiting field processing, San Ysidro.

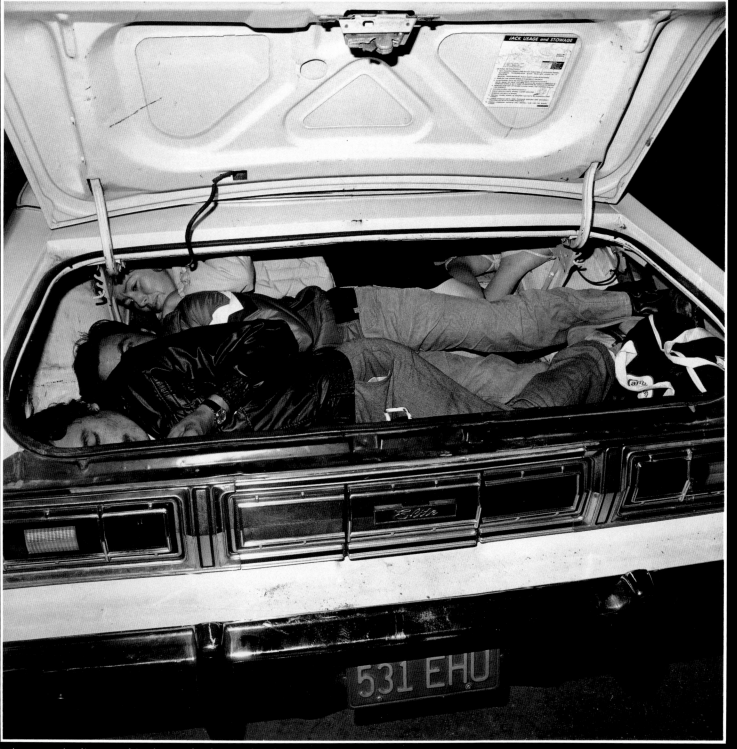

Indocumentados discovered in the trunk of a car abandoned by their *coyote*, San Ysidro.

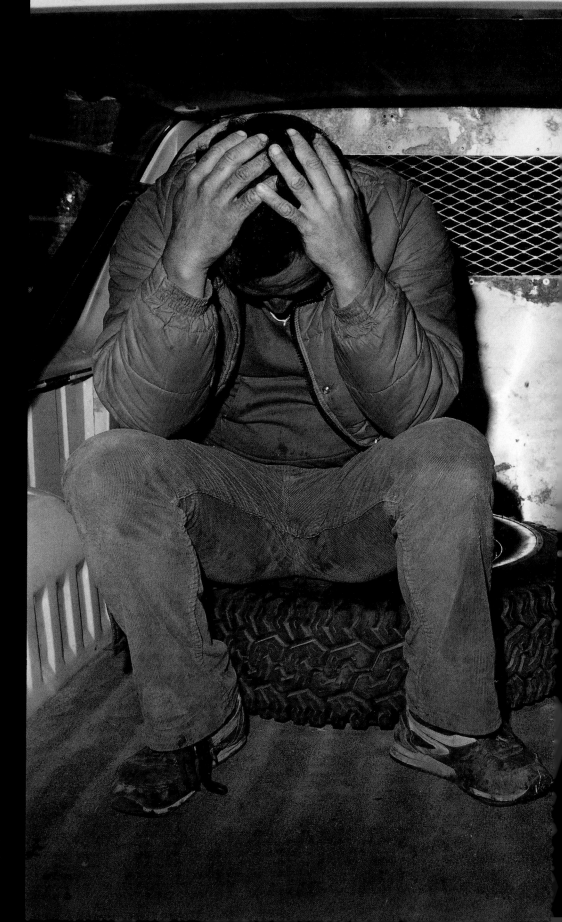

Apprehended father and son in the back
of an INS truck, San Ysidro.

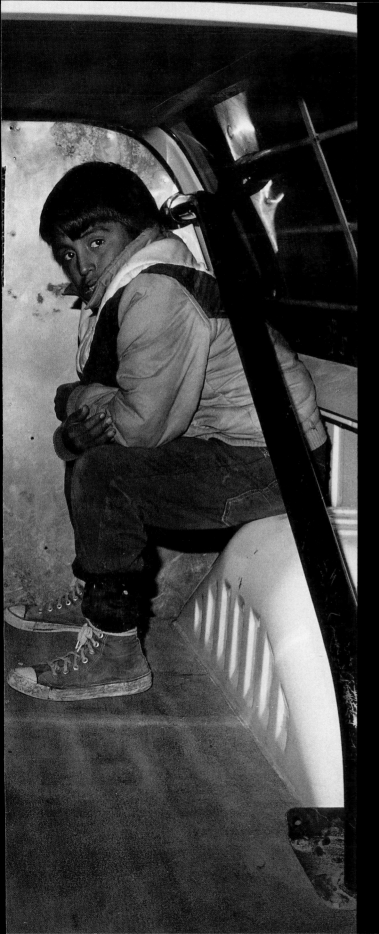

What will you tell your people about immigration?
That it's chasing people in the fields. And there are times when you get caught and there are times when you don't.
Do you lose sleep thinking about immigration?
No, not me.

—Macedonio S., 21,
San Juan Mixtepec, Oaxaca

El Norte

*They told me many pretty things.
That life here was easier, and so I
came.*

—Ruben V., 16,
Guadalajara, Jalisco

*Like my friend says, I thought
that this was a paradise, that one
lived like a king or queen. But it
is just the opposite. We live like
slaves.*

—Leonor R., 23, Tepejillo, Oaxaca

*We thought we'd sweep up the
money, but not so. There's no
sweeping up the money, because
there are no brooms.*

—Saul G., 23, Oaxaca

Roadside sign, San Ysidro.

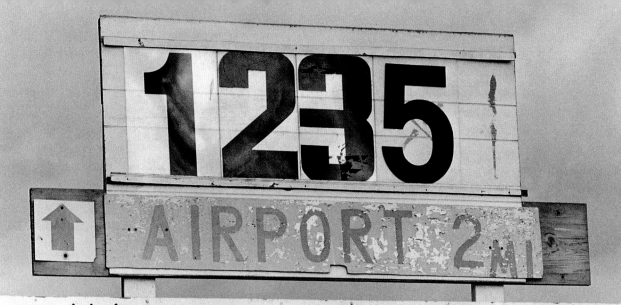

MONEY EXCHGE.
— ONE STOP —
FINE FOODS, AND WINES
CHECKS CASHED, PESOS
AUTO INS. TOURIST INFO.
LAST-CHANCE IN USA

1235

↑ AIRPORT 2 MI

What I liked—and what impressed me: It's easier to get a car. Here in the U.S. people do not walk a certain distance. They have to have a car to go from one place to another. Otherwise, one doesn't go anywhere. It's easier to get one here. In Mexico, no matter how hard one tries, it's impossible to get a car.

—Miguel M., 29,
Santa Cruz Mixtepec

II. San Jeronimo, U.S.A.

The Indians from San Jeronimo Progresso sometimes speak of Baja California and the southernmost part of the state of California as if they were one region—not quite the United States but far different from any Mexico they know. The international border slicing through it is almost irrelevant.

Conditions are dismal on the megafarms in Mexico's Baja— vast agricultural stretches that produce not for Mexicans but for the supermarkets of the United States. Seasonal laborers on the farms are called *golondrinas* or "swallows," because they come and go. On the Baja farms some 70 to 80 percent of the "swallows" are Indians from Oaxaca, according to Alberto Hernández of the Mexican Center for Border Studies. Adults and children may pick fruit and vegetables for up to 12 hours, often with no break, for the equivalent of $2 to $3 a day.

But even on the U.S. side of "the line," higher wages are offset by greater costs, the lurking danger of deportation, and work conditions that may not be much better. At a farm growing strawberries north of San Diego I visited about a dozen men and

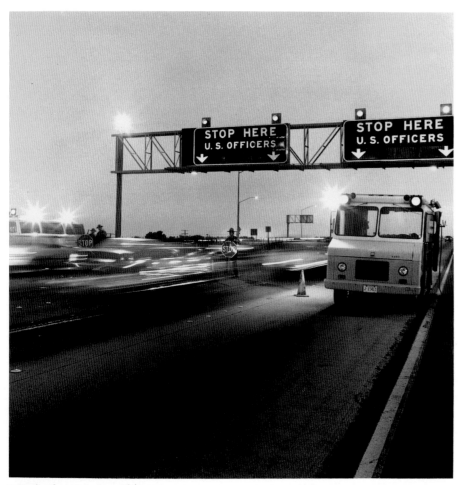

INS check point, San Clemente.

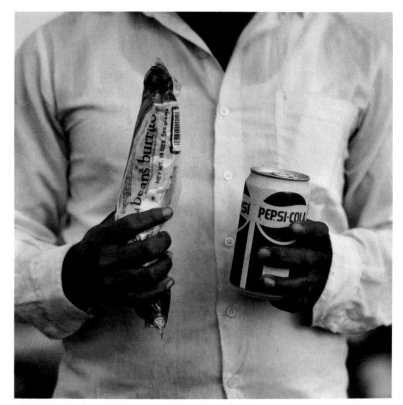

Microwave burrito and Pepsi, northern San Diego county.

68

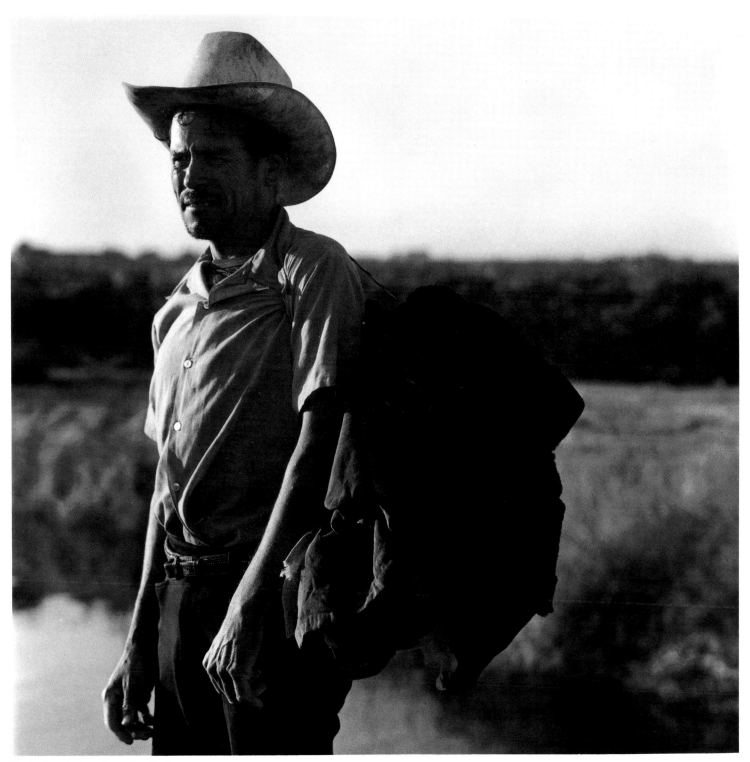

Recienllegado (newly arrived), Fresno.

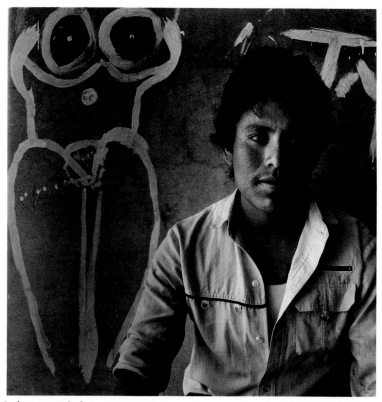

Indocumentado from Oaxaca, Fresno.

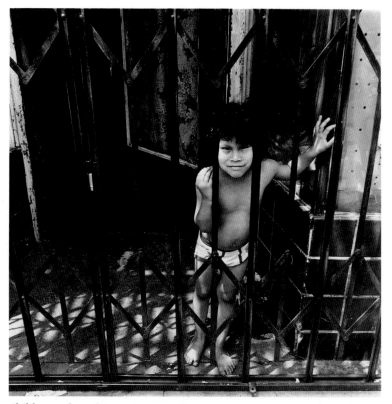

Child, storefront home, Los Angeles.

boys from San Jeronimo who were working as pickers; some were as young as 13. They were living in a ravine under plastic tarps strung from tree branches. There were no showers or toilets, only open fields and ditches for the men to use as sanitary facilities. To cook their food and keep warm they burned wood from scavenged pallets. When a teenager named Jose lugged water from an irrigation outlet to make coffee, I noticed the container he used had once carried insecticide. Although the warning "Discard after use" appeared in Spanish and English, none of the men read either language.

The grower who owned this strawberry field on the edge of a fashionable housing development did not guarantee work on any given day. At week's end, he deducted money from paychecks for "social security" and "disability insurance," although the men said injured workers in fact were neither reimbursed nor treated. When one of the men was killed in a tractor accident, the grower did pay for shipping his body back to Mexico, they said. I saw several of the men's paycheck stubs that bore the same social security number: 000-00-0000.

It took me a long time before I ate those McDonald's. I didn't go out. When we got to San Ysidro, the person that was bringing us had us locked up. We could not go out for anything. If we wanted to eat, food was brought in to us. Even after arriving in Fresno, it took me a long time before I could go out. I came straight home after work, because I was afraid of being deported. You know the situation.

—Narciso P., Michoacán

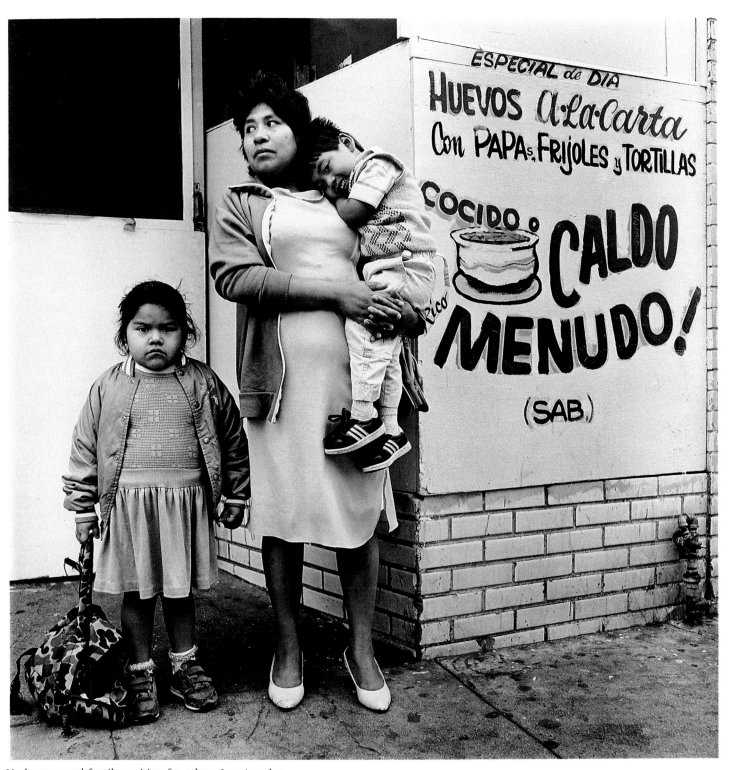

Undocumented family waiting for a bus, Los Angeles.

Migrants without documents say it is often harder to penetrate Border Patrol checkpoints some 50 miles north of the border than it is to sneak across "the line" itself. Once they are in the United States and working, however, residents of Mexican villages such as San Jeronimo can send home enough money in three months—usually in the form of postal money orders—to buy sufficient corn to feed their families for a year. Making non-union wages, Indians from San Jeronimo might expect to earn about $75 a week in the United States, according to U.S. academic researchers who interviewed families in the village. The figures are based on ideal conditions in season. Weeks without work can mean disaster, and getting caught by *la migra* is a catastrophe which can wipe out savings and necessitate another trip north made in an atmosphere of even more urgency.

When they are deported, or want to see family, or, as in one case I know, need medical treatment but are afraid to go to a clinic in the States, the migrants can go to Tijuana to regroup without having to travel all the way back to Oaxaca. Yet because the flow from the village is so constant and because increasing numbers of residents do travel all the way home for short periods as they secure modest stakes up North, news from San Jeronimo stays fresh. Indeed, in a certain way, the village of San Jeronimo now exists beyond its original geography all along the migrants' trail.

Once I visited one of the village's farthest-flung outposts, a rural enclave of shabby trailers that felt at first like a scene out of *Grapes of Wrath*. A man sat repairing one of the large canvas shoulder bags ubiquitous among those who work the citrus-picking jobs. A woman took her young daughter across the road to a field where they found an irrigation spigot and washed their hair. We were somewhere outside Riverside, California, but in some ways we might as well have been in San Jeronimo. The two dozen or so men, women, and children at the camp spoke Mixtec. The women kept their hair braided in the village style. When one young man appeared with several pots of cooked chicken, the campers gathered around a long table outdoors to eat communally.

Raul and Juana Garcia, a son and daughter-in-law of Lorenzo Garcia, arrived at the settlement that weekend looking tired. Though bug-eaten and penniless, they were in high spirits—flushed with a kind of success at having completed the long journey from San Jeronimo. I hardly recognized them from the last time I had seen them sitting on the dirt floor of the family house in the village. Instead of her woven Indian dress and shawl, Juana now wore a pair of cheap polyester pants and left her hair unbraided, a sort of traveling camouflage. "We left my father's house on February 27," said Raul. "In March we

Sometimes when the body is tired, when one needs a drink or a rest, well the people who want our last drop don't give us a chance. Always with the slogan: There are more people.

How do you feel living in a place where you hardly speak the language?
Well, to make a comparison, like a cockroach. To be able to grow, to stand out, it's very difficult, very difficult. But not impossible, and one always tries to move forward.

—Agustin P., 24, Jalisco

Makeshift home, northern San Diego county.

72

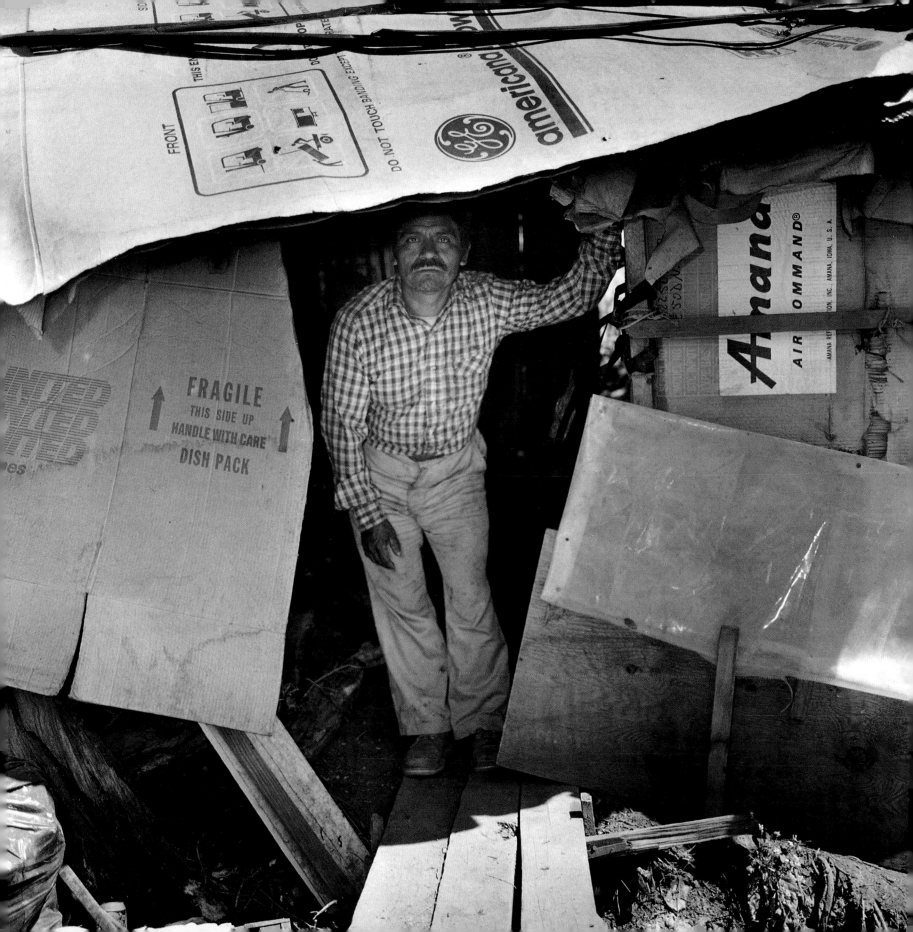

reached our people living in Tijuana. In May we crawled across the border and started walking north at night, keeping away from the highways." The walk took two weeks.

It is clear the villagers of San Jeronimo Progresso maintain their exodus out of strict necessity. It is also clear they nurture their links to the village and consider it home even after years away. Some have taken children back for short periods to acquaint them with the village they never really knew. It is still too early in the history of this migration to know whether or not the children now being born on the trail will come to call San Jeronimo home.

At the end of one day during my visit to Jorge Gonzales in Tijuana, he brought out a stack of snapshots taken three years earlier on his last trip home. He spread them proudly over the surface of a rough wooden table. His two teenage daughters stood by and watched respectfully, but seemed bored. They

were toddlers when they arrived, and I suspect they think of home as Tijuana—not that tiny mountain village a world away—"Here is our house," said Gonzales almost defiantly, pointing to a picture of a modest cinder-block structure with the tall Mixtec mountains in the background. "I'm going back there some day. All this is just temporary."

On the other hand, in Riverside, the father of the young girl who was washing her hair under the irrigation spigot told me of his plans for his child's high school and college educations here in America—"school she could never get if I stayed home, or we went home, and school that will let her be whatever she wants because she is already so smart." The girl herself, a 10-year-old named Irma, told me that at school she speaks English to her teachers and Spanish with her friends, but that outside this campground she hides the fact that she also speaks Mixtec so people won't think she is "a little backward."

Whether they are determined to stay in California or dream of going home, the absent sons and daughters of San Jeronimo Progresso remain under the strong pull of their village despite all their wandering. Those who can return temporarily do so especially during the annual fiesta in September, when the population swells and the village buzzes as it did in the old heydays. The fiesta is a major religious and civic event rooted in an Indian tradition that reaches back into the centuries. Town fathers have long required that each year one of the citizens finance the event—at huge cost.

Since so many families have gone north, this tradition has a new twist. Those who have left to earn pesos or dollars are now chosen to be the responsible parties, even if they must fulfill their duties—and send money—from a long distance. To the envy of surrounding towns, whose residents are just beginning to emigrate north themselves, the festivals of San Jeronimo are grander than they have ever been. □

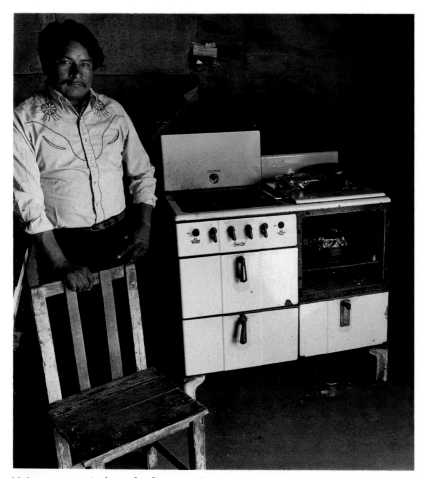

Living quarters in barn for fourteen Oaxacans, Fresno.

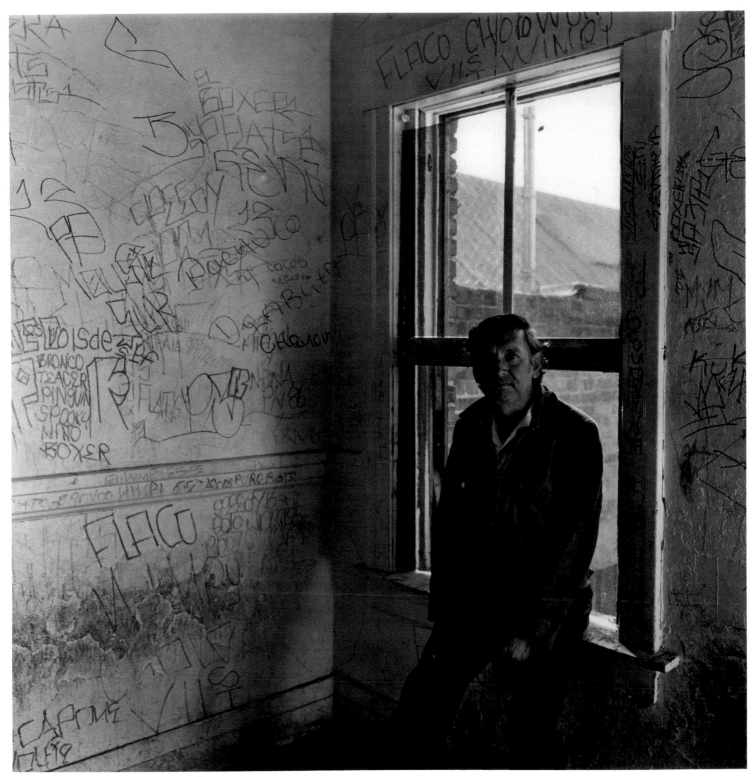

Living quarters, tenement, Los Angeles.

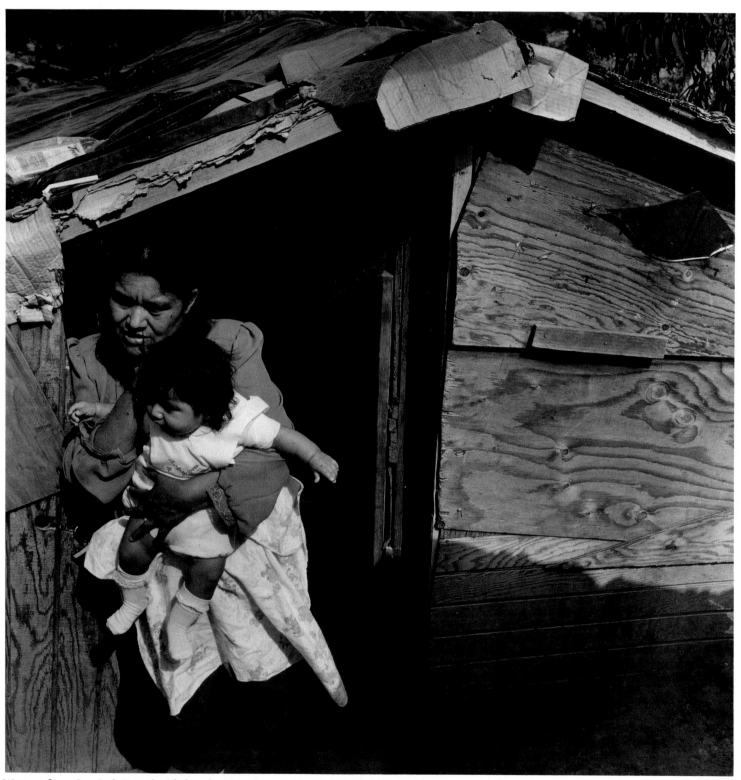

Woman from San Luís Potosí with her daughter born in the U.S. in their home, northern San Diego county.

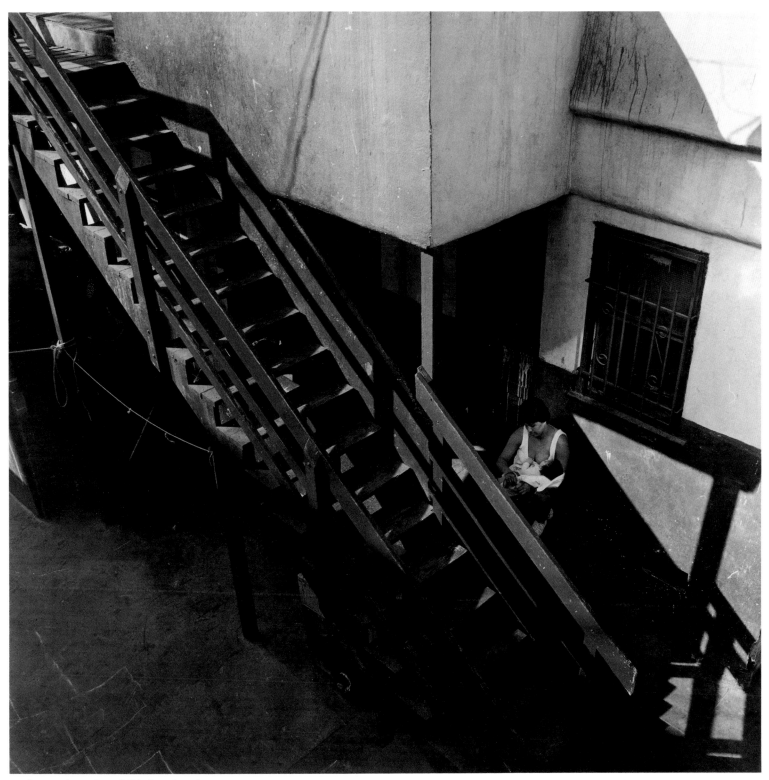

Mother and nursing child, Los Angeles.

I made it to a country that people who don't have much experience call the "country of opportunities." Others call it that even knowing the opportunities aren't really that easy. You have to look for them more than anything. The ones that get the opportunities are the ones that have money, not the ones that come poor. The people that come from Mexico and other countries don't have any opportunities, at least that's the way I see things. I've looked in many different ways, and I'm still a poor person. For instance, if you go to prune the vines you earn $250 a week. Then you have to pay $180 for rent. With what's left you have to pay electricity, telephone, water, and many other things, besides all they deduct when they give you your check, so you don't have anything left over. And that's what they call the land of opportunities.

—Emilio N., 23, Guanajuato

What I remember the most is first of all my family, my parents, brothers, relatives. Then I miss those times when the rain would fall and we would be pasturing the animals in the open, there in the mountains. Then we would go with the animals to our town, to the house, and get there and find a warm dinner ready. Then go to sleep and wake up ready to begin another day.

—Angel N., 24, Guanajuato

Child of undocumented family, Fresno.

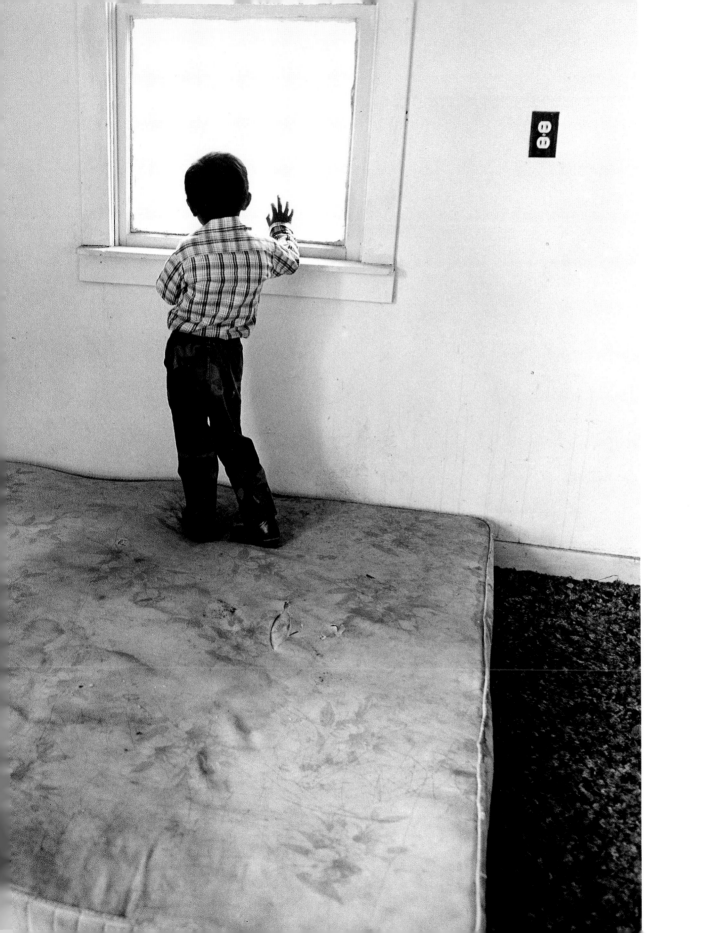

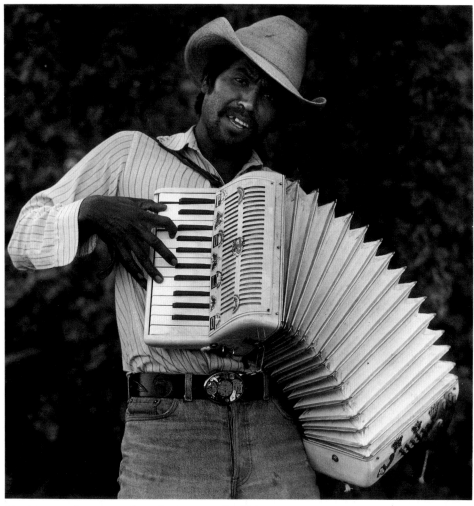

Musician, undocumented worker's camp, Healdsburg.

After crossing the line I reached some friends on the edges of San Ysidro, in Encenitas, California. I thought the people in the U.S. live very differently from the way we do in the South, so I was surprised to find these friends staying in little houses they made themselves. They were totally isolated from the city and from the nearest town. They were practically in the middle of nowhere, growing tomatoes. In truth, I was disappointed. I said, ''Is this what you call the U.S.?'' All that disappointed me more than anything.

—Angel N., 25, Guanajuato

If Mexico was the same as here, one would only come to look at the gringos . . .

—Ruben V., 16,
Guadalajara, Jalisco

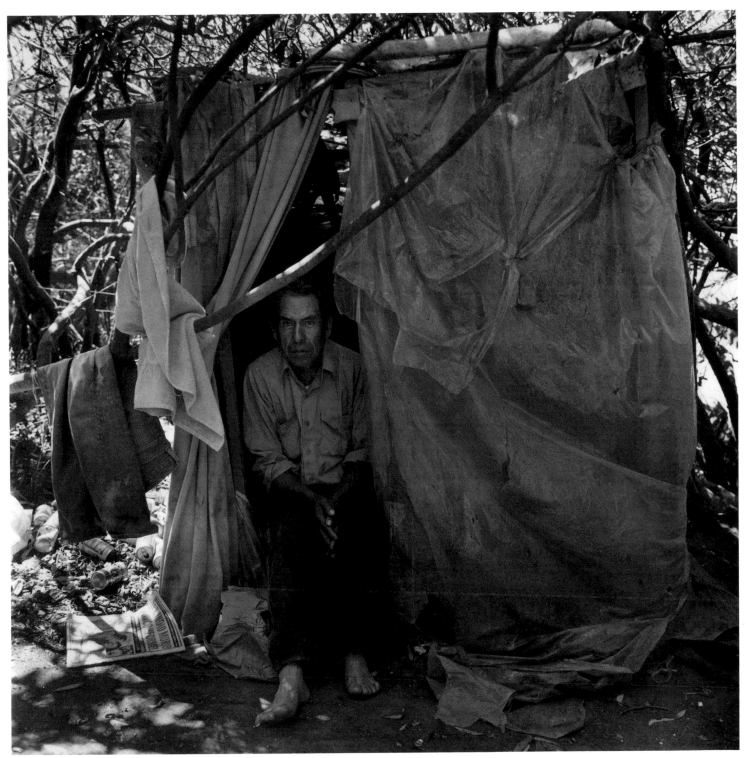

"Hooch," northern San Diego county.

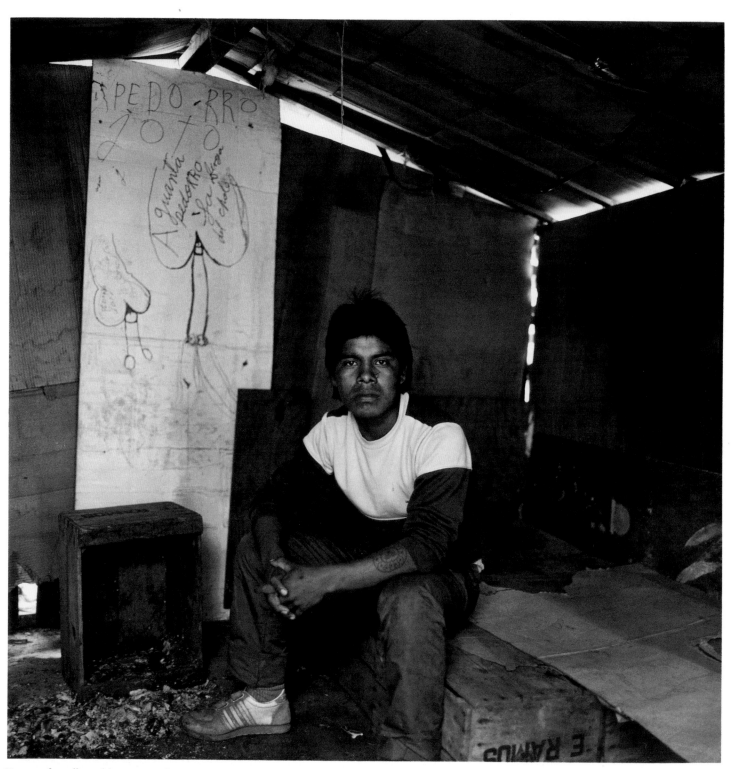

House of cardboard boxes, northern San Diego county.

Will you be able to legalize under the new law?
No. That law was made for . . . Well I don't know for whom, not for me.
And won't you apply for the amnesty?
No, it's not possible. I don't even want to live in this country. I want to return to my people.

—Saul G., 23, Oaxaca

My plans? Right now with the amnesty, I think it's a good opportunity for me, right? Once I have this permit, it's not that I want to stay, but it's a good opportunity to be able to study something like carpentry, electricity, mechanics, etc. Then if one wants to return to Mexico, well one returns to Mexico. Over there one doesn't have the means to study.

—Florencio S., 23, San Juan Mixtepec, Oaxaca

Before the new law, there was a lot of talk. For example, I had the idea that the day it was signed all those people who are here illegally would all be automatically legalized. But the law was signed, and in reality everything has been disastrous, because all the media are saying something different.

—Angel N., 25, Guanajuato

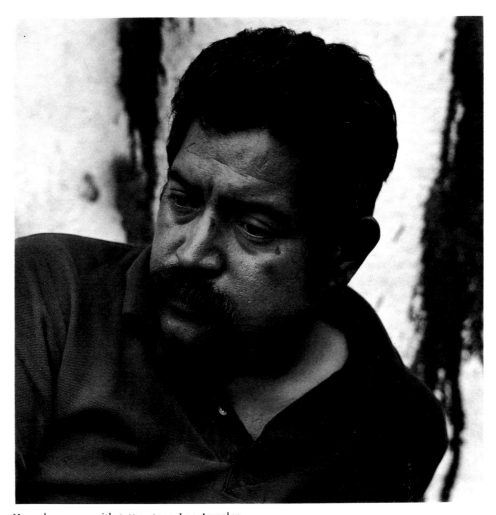

Homeless man with tattoo tear, Los Angeles.

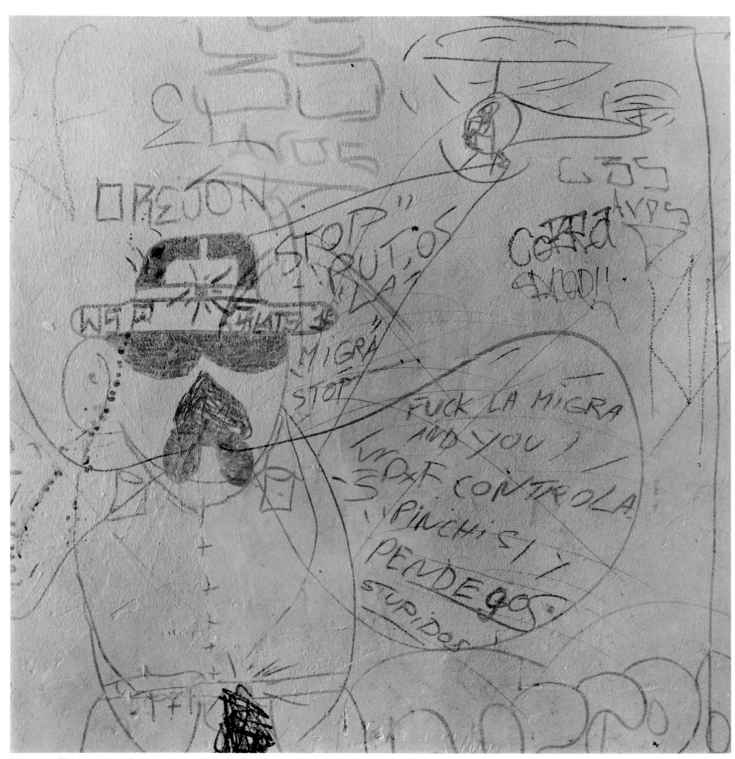

Migra graffiti, Los Angeles.

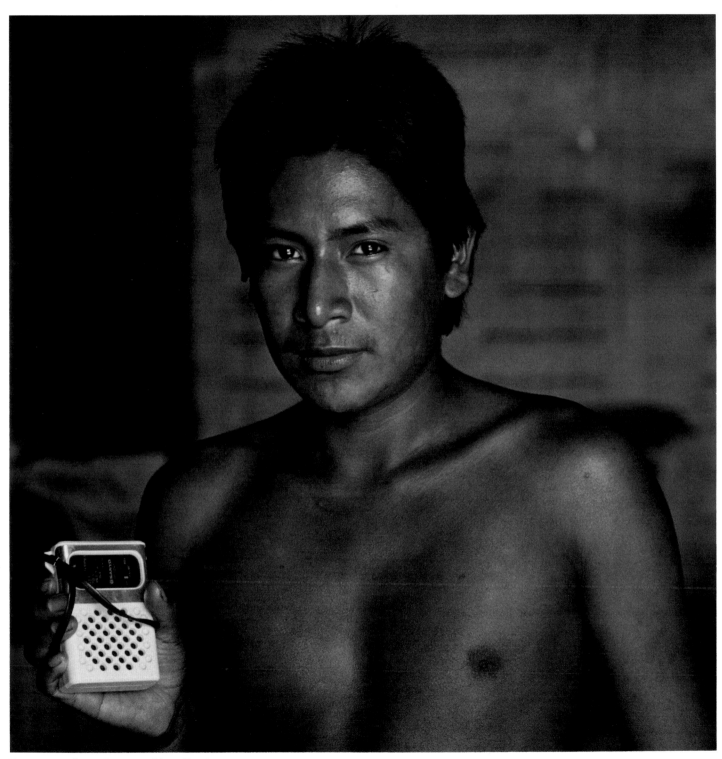

Young man from Oaxaca with radio, Fresno.

The first thing I saw when the coyote brought me here was a bunch of drug addicts and weird people. I thought this was not the United States, because in Mexico I was told all these nice things about education and good people and all. But that's not how I see it. The majority of people here are drug addicts.

—Miguel P., 23,
San Juan Mixtepec, Oaxaca

I miss Mexico. Many times the monotony in which I live becomes part of myself. I miss the trips on buses, on the Metro, the relation-ship with people you see every day, the communication. I miss my family, the news in Spanish that I hardly ever get here.

—Nelly H., 26, Mexico City

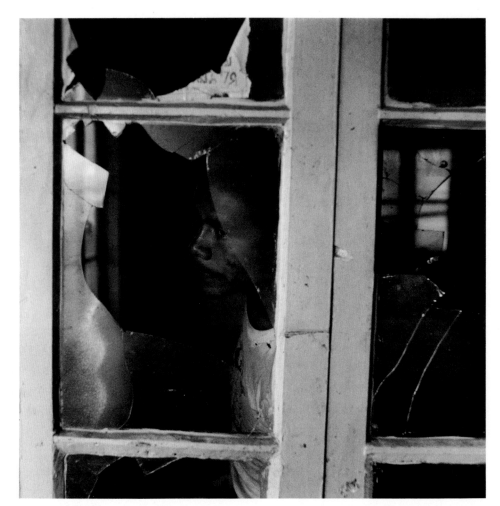

Tenement dweller, Los Angeles.

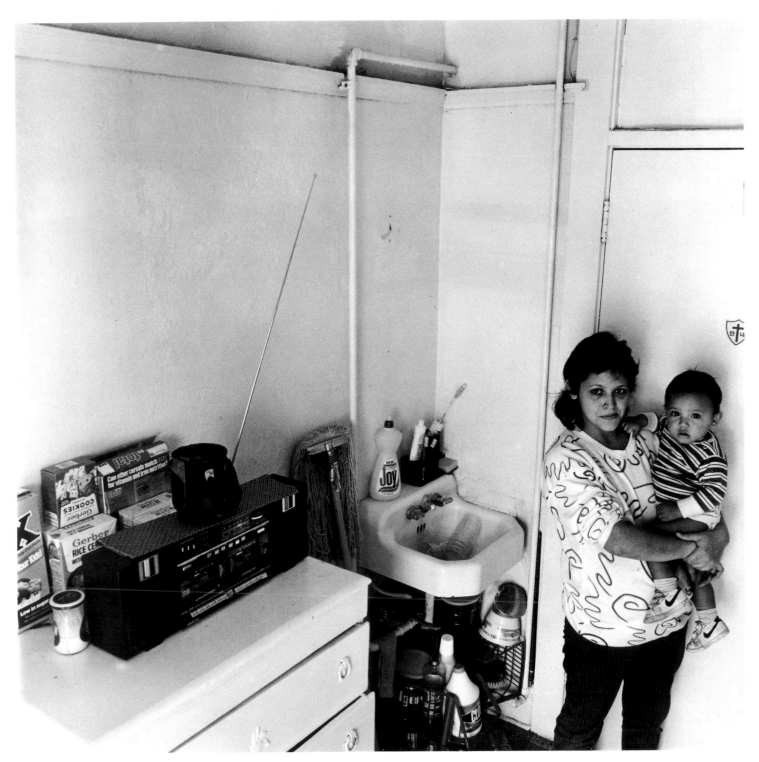

Room with a sink, 6th Street, Los Angeles.

I raised my children here and educated them here. They have it all. This a country which offers opportunities, and that's the reason I'm here: for my family, for my children, because they are from here.

—Narciso P., 36, Michoacán

I think the gringos think we come to take something away from them, their traditions, and even their work. I get the impression they think we take their customs away.

—Antonio M., 24, Jalisco

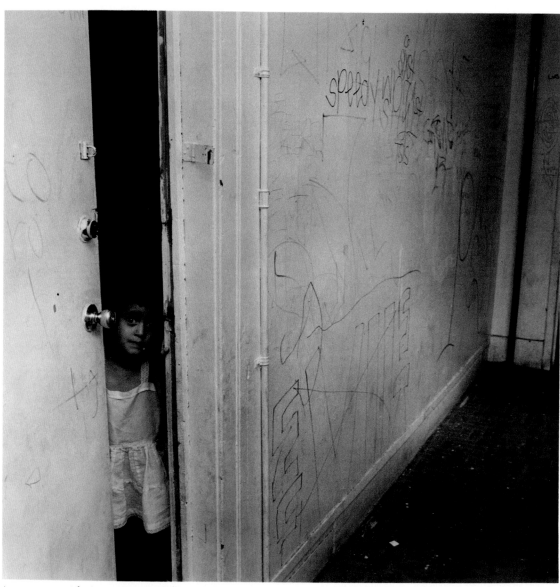

Apartments, 6th Street, Los Angeles.

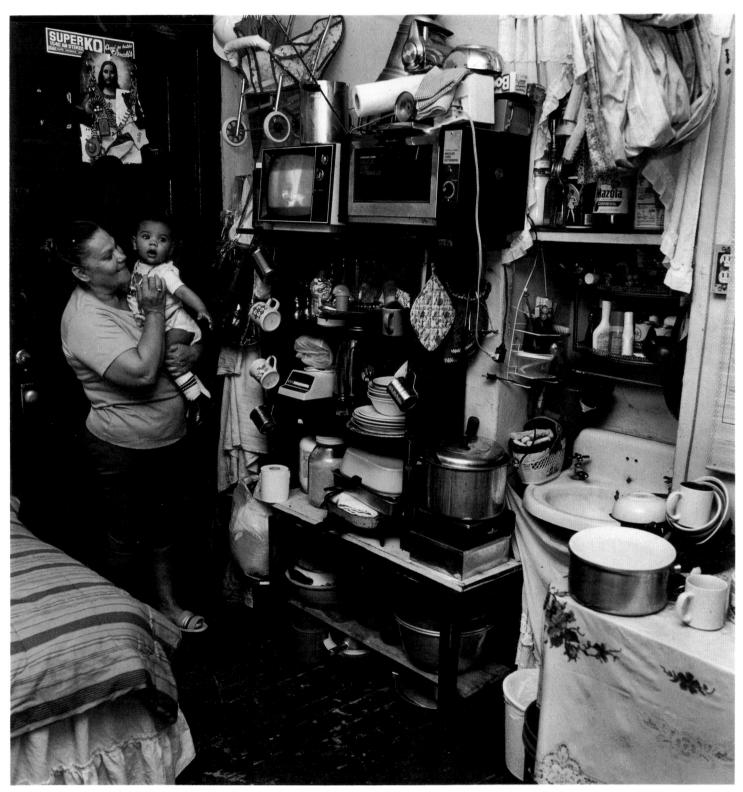

One-room apartment, 5th Street, Los Angeles.

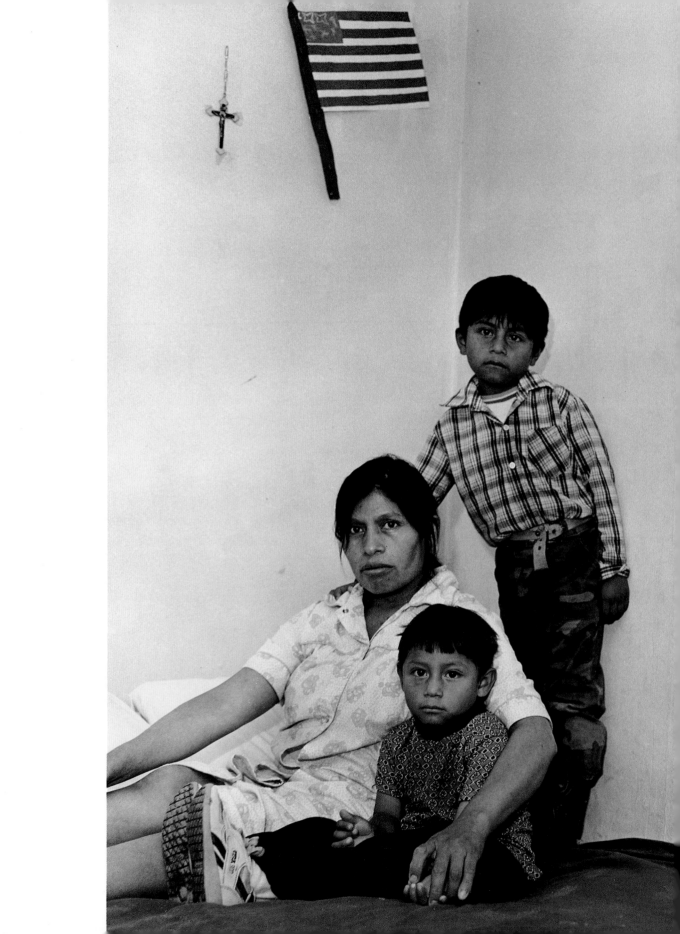

A new life, family from Oaxaca, Fresno.

Acknowledgments

A book is never the undertaking of only one person. Many friends and colleagues have assisted in its creation:

Candido Morales, my friend and guide in Oaxaca. Rafael Morales, who came north in the 1950s and has continued to share his good fortune with his fellow countrymen.

Edgardo Ornate for guiding me on my first trip to Mexico. Bernardo Cruz and Filemon Lopez. Hugo Morales for his insight and encouragement. Samuel Orozco for his oral histories and for making himself always available to help arrange contacts for my many trips. Jose Gonzalez, Pablo Quiroz. Myrna Martinez for assistance in Fresno and Sinaloa, Mexico. Gregorio Sanchez and Camilo Ramirez, guides in Windsor, California. Angel Ruiz Geeogan, my friend and driver in Tequixtepec, Oaxaca. Roberto L. Martinez (AFSC/San Diego), Marco V. Guerrero (*Los Ninos de La Frontera*), Martin De La Rosa (Center for Border Studies). The Rev. Rafael Martinez, Solana Beach, California. The help and good work of Alice Callaghan, Anne Marie Rivera, and especially Adam Leventhal of *Las Familias del Pueblo* (Los Angeles).

For sharing their homes on my many trips to L.A., Barton and Pam Wald, Bob and Gail Israel, Ira and Judy Gottfried, Gary Grossman and Richard Gottfried.

For contributing film for my work in Mexico, Barbara Hitchcock, Polaroid Worldwide Creative Programs. My thanks to Michele Vignes and Kim Komenich for always being willing to look. Roberto Hinestrosa in Tijuana for many good times and trips to Canyon Zapata.

The continuing support of Kirke Wilson, Carl and Edward Levinson and Helen Doroshow is greatly appreciated. Sandy Close at Pacific News Service for her ideas and concerns. Richard Rodriguez for his conversations and essay. My editor at California Historical Society, Martha Winnacker for her faith in my work. Christy Hale for her design. My editor at Aperture, Steve Dietz, whose ideas, aesthetic values and conversations helped push this book to completion.

I am especially thankful to my sister Susan Light who has always been there when I needed her for support, friendship and conversation, and to my parents, Stanley and Dorothea Light.

For my son Stephen who kept me grounded during the four years of this project, and Susan Spann for her support during the last phase of this project.

I thank the many friends of Tequixtepec who shared friendship and drink while in Oaxaca.

The support of the National Endowment for the Arts and a Dorothea Lange Fellowship were critical in continuing this project.

And finally to the many people who opened their homes and lives to my camera on both sides of *La Frontera* with the hope that their voices would be heard . . . thank you.

Statements from Mexican immigrants contained in this book were taken from interviews conducted in Spanish late in 1987 and early in 1988 by Samuel Orozco. Edited English translations of the complete interviews have been deposited in the library of the California Historical Society in San Francisco.

Aperture Foundation gratefully acknowledges the support of the Rosenberg Foundation, The Max and Alma Levinson Foundation, Pacific News Service, and the Friendship Fund in making this publication possible. The work was supported by a grant made to the photographer from the National Endowment for the Arts and by a Dorothea Lange Fellowship. Pacific News Service's Hispanic America Project is funded in part by the Ford Foundation. Mary Jo McConahay's research was funded by a grant from the Fund for Investigative Journalism.

Composition by David E. Seham Associates, Inc., Metuchen, New Jersey. Printed and bound in Hong Kong by South China Printing Company.
Library of Congress Catalog Number: 87-73574
ISBN: 0-89381-324-9
The staff at Aperture for *To the Promised Land* is Michael E. Hoffman, Executive Director; Steve Dietz, Editor; Lisa Rosset, Managing Editor; Stevan Baron, Production Director; Jason Greenberg, Tessa Lowinsky, Editorial Work-Scholars. Editorial Director for California Historical Society: Martha Kendall Winnacker. Book design by Christy Hale.

Aperture Foundation, Inc., publishes a periodical, books, and portfolios of fine photography to communicate with serious photographers and creative people everywhere. A complete catalog is available upon request. Address: 20 East 23 Street, New York, New York 10010.

The California Historical Society publishes a periodical and books, maintains a library and photographic archive, and sponsors exhibitions, tours, and public events to encourage the collection, preservation, and interpretation of California's multi-cultural, multi-ethnic history.